IMAGES
of America
EARLY POMONA

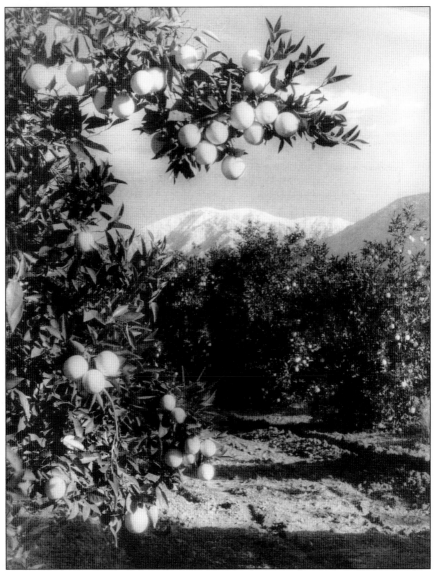

This early-1900s photograph shows snow-capped Mount San Antonio, commonly called "Mount Baldy," in the background and a Pomona orange grove, laden with fruit, in the foreground. (Photograph by Frasher; courtesy Historical Society of Pomona Valley [HSPV].)

ON THE COVER: The cover photograph is of orange pickers in a grove in Pomona. The young man on the top of the ladder is Ward Batsford, who later owned the Pomona Broom Factory at 860 East Second Street. (Courtesy HSPV.)

IMAGES of America
EARLY POMONA

Mickey Gallivan and
the Historical Society of Pomona Valley

Copyright © 2007 by Mickey Gallivan and the Historical Society of Pomona Valley
ISBN 978-0-7385-4776-3

Published by Arcadia Publishing
Charleston SC, Chicago IL, Portsmouth NH, San Francisco CA

Printed in the United States of America

Library of Congress Catalog Card Number: 2007923839

For all general information contact Arcadia Publishing at:
Telephone 843-853-2070
Fax 843-853-0044
E-mail sales@arcadiapublishing.com
For customer service and orders:
Toll-Free 1-888-313-2665

Visit us on the Internet at www.arcadiapublishing.com

This book is dedicated to the many individuals who served Pomona as tireless members of the Historical Society of Pomona Valley's board of directors throughout the Historical Society of Pomona Valley's 91 years of existence, for without their dedication, many of the historical landmarks and most of the photographs included in this book would not have been preserved and would no longer exist today. We owe these individuals eternal gratitude for their foresight and devotion to preserving the rich and colorful heritage of Pomona for the education and enjoyment of future generations. Thank you for your valuable service to the people of Pomona.

Contents

Acknowledgments 6

Introduction 7

1. Adobes of Rancho San Jose 11
2. The Village of Spadra 23
3. The Center of the Valley 31
4. The Gems of Pomona 65
5. Garden Spots of the Valley 89
6. The City of Churches 105
7. The City of Technology 113

ACKNOWLEDGMENTS

I wish to thank Bruce Guter, systems manager of the Pomona Public Library, and his staff and volunteers, who diligently identified, organized, catalogued, digitized, and preserved the many photographs, documents, and other items placed in the care of the library by the Historical Society of Pomona Valley. Thanks also go to the library in general for cataloguing Pomona history throughout the past century. I want to thank Bruce for his help in locating the photographs needed. Without his assistance, this book would not have been possible.

Thank you to Dr. William King for his encouragement and assistance. In his quiet way Dr. (Bill) King always offers great advice and reassurance. I also want to thank Dr. King for obtaining the photographs of the Native American collection, as they are an integral part of the development of the community.

Thank you to Candelario Mendoza, who has been an outstanding member of the Pomona education system for many decades, first as a teacher, then as a principal, and most recently as a member of the Pomona Unified School District Board. Mendoza is an active member of the Historical Society of Pomona Valley and a strong supporter. Thank you to Paul McClure with Pomona Unified School District.

Thank you to Kathy Adkins, Brooke Brunzell, Gayle King, Charlene Wyatt, and Sandra Posey for their assistance in the production. Thank you to the members of both the 2006 and the 2007 Historical Society of Pomona Valley Board of Directors for their endorsement of this book and for their commitment to preserving the history of Pomona.

I wish to thank my husband, Jim Gallivan, for his very valuable help in the technical area and for his wonderful unconditional support and encouragement.

A special thank you to Mike Showalter and Mark Brandt for their generous contribution of items related to Pomona's past, many of which have been tremendously helpful in the creation of this book, and to the many members of the community who have so generously donated photographs to the Historical Society of Pomona Valley.

A very special acknowledgement goes to the late Fred Sharp for his recognition of the need to preserve outdated city photographs and documents, which he diligently kept in his garage for later use by the Historical Society of Pomona Valley. And thanks to his wife, Muriel.

The two main sources for photographs were the Historical Society of Pomona Valley and the Pomona Public Library. If a photograph came from the archives of the Historical Society of Pomona Valley, it was credited, "Courtesy HSPV."

INTRODUCTION

Many milestones mark the rich history of the area now known as Pomona. The entire valley was originally occupied by the Tongva people, who lived relatively undisturbed for thousands of years. The arrival of the Spaniards in 1769 brought an end to the isolated way of life for the Tongva.

The Tongva people were hunters and gatherers and lived in many villages, generally near streams and rivers, to access a ready source of water. The complex and varied culture of the Tongva was spread throughout the Los Angeles basin. One of the villages was located near today's San Bernardino and Towne Avenues, as there were several artesian wells in the vicinity. Another village was located in today's Ganesha Park near the San Jose Creek.

By 1800, San Gabriel had over 1,000 natives at the mission: 1,953 had been baptized, 869 had been buried, and 396 couples had been married. The Tongva people did not fare well under the control of the mission, as many were forcibly removed from their villages to be Christianized and used for labor at the mission.

The Tongvas worked as laborers on the ranchos and trusted the Spanish people. A smallpox epidemic in 1862 and 1863 almost completely wiped out the native population. It is estimated that when the Spanish settled in what is today California there were 250,000 natives, but by 1910, the native population had dropped to 16,350.

The Spaniards established the first European settlement in the area, Mission San Gabriel, near the San Gabriel River. Flooding destroyed the first mission buildings, and the mission was rebuilt at its present location in 1776. Although San Gabriel was the fourth mission to be built, by 1790, it surpassed all other missions in livestock and farm products. All of the land east of the settlement belonged to the mission, including present-day Pomona.

After Mexico became independent from Spain in 1821, a movement began to reduce the power of the missions. In the mid-1830s, much of the land was freed for private ownership. Don Ygnacio Palomares and Don Ricardo Vejar petitioned Mexican governor Juan Batista Alvarado for 15,000 acres of vacant land, known as Rancho San Jose. On April 15, 1837, the petition was granted, and the two families, with a small herd of cattle, set out for their new home. Don Ygnacio built a small adobe near the present-day Los Angeles County Fairgrounds on the northern part of the land. Vejar built his adobe on the southern part near present-day Cal Poly.

The rancho prospered from the very beginning, as water and food for the cattle were readily available. After the discovery of gold, both Palomares and Vejar gained great wealth from the sale of their cattle to the new residents of the many gold-mining settlements. In the early 1850s, Palomares built a new 13-room adobe on what is today Arrow Highway, formerly Cucamonga Road. The Vejar family built an adobe on the bank of the Pedregoso Creek near where the Phillips Mansion is located today. Later Vejar built a spacious, two-story adobe in what is today the city of Walnut. Vejar's ranch was a working ranch and the center of activity, with a reputation in 1846 for containing "agreeable people fond of festivities and industrious." In 1858, the Vejar Rancho became a stopping point for the Butterfield stage.

After statehood in 1851, the area was divided into townships and each township heavily taxed. The end of the Gold Rush in 1857 began a period of hardship for the families, as extreme droughts, floods, and locust infestations besieged the area. Vejar lost his part of the ranch in 1863, as he had mortgaged it to pay off other debts and was unable to repay the loan and the large amount of interest. The Palomares family continued to own their section after Ygnacio died in 1864 and eventually sold it in small sections in the 1870s to new settlers for farms.

Vejar's section went to two merchants from Los Angeles who hired Louis Phillips to manage the ranch. Phillips had been very active in farming, stock raising, real estate, and other enterprises. He already owned several properties in downtown Los Angeles and was described as having "thrift and enterprise characterizing his life." Almost immediately, he was appointed as judge of the plains with the responsibility of settling disputes between the local cattle ranchers. Phillips lived in the Vejar adobe and was able to buy the ranch for himself in 1866. He raised cattle and sheep and farmed the land. Phillips was very successful in his ranching endeavor.

Soon after purchasing the large ranch, Phillips began selling small parcels of his ranch land to individuals on which to establish small farms. He sold 100 acres to William Rubottom ("Uncle Billy") to establish a hotel and tavern near Phillips's home on the Lower San Bernardino Road. When the U.S. Post Office was established, Rubottom named the community Spadra, after his hometown of Spadra, Arkansas, and it soon became known as the home of Uncle Billy Rubottom's Tavern. By 1875, Spadra was a thriving community with a cluster of blacksmith shops, stores, and other commercial establishments. Not only did horse-drawn traffic utilize the establishments, but also the first leg of the Southern Pacific Railroad line, running east from Los Angeles, terminated in Spadra.

For several years, the village prospered, and the residents hoped Spadra would be the main station stop for the railroad, leading to continued growth and prosperity, but it was a major disappointment to the community when the railroad decided to make their main stop in the city of Colton. The first locomotive to go through Pomona going east was on July 16, 1875. As Pomona, led by well-organized and financed city leaders, became the center of the region by developing an economy based upon citrus, Spadra entered a period of slow, gradual decline. Today the only remains of the once-thriving village are the Spadra Cemetery and the Phillips Mansion. The area that consisted of Spadra was annexed by the City of Pomona in 1955.

In 1868, Charles Loop bought 160 acres surrounding the Adobe de Palomares on which he planted vineyards. In 1873, Loop and his friend Alvin Meserve bought 220 acres on which they planted a variety of fruit and olive trees. This vineyard was the beginning of the huge grape industry in this part of the country. In 1874, Meserve and Loop purchased more land and began subdividing it into the Meserve and Loop Tract. In 1877, Meserve and his family moved into the Palomares Adobe. Both Loop and Meserve are identified with the rapid growth and the development of the horticultural resources of the community.

In 1870, Cyrus Burdick and his wife, Amanda Chapman, settled in what is today Pomona. Two years later, Cyrus planted 500 seedlings at night with Amanda holding the lantern, as they believed it would help the seedlings to produce better. He reactivated the old *zonja* system, which had been developed by Ygnacio Palomares in 1847, to water the young trees.

In 1874, Cyrus Burdick, P. C. Tonner, and Francisco Palomares obtained control of approximately 3,000 acres of land. Some of the land was purchased outright, and some of it was obtained on contract from Louis Phillips. Mrs. Francisco Palomares, the former Lugardo Alvarado, also obtained from Conception Palomares the rights to all water rising and flowing through the base of the San Jose Hills, the right to develop more water, and the right to maintain necessary ditches and reservoirs with two reservations. Cyrus Burdick, P. C. Tonner, and Francisco Palomares developed the first cooperative citrus grove in Pomona, consisting of 3,000 acres and water rights on Rancho San Jose.

The trio planned to subdivide the land into tracts but was unable to obtain the financing necessary for the project. In 1882, they sold the land and the water rights to a group of speculators who had formed an association, the Los Angeles Immigration and Land Cooperative Association (later the Pomona Land and Water Company), for $10,000. The association, consisting of Thomas

A. Garey, president; J. T. Gordon; Luther Holt; J. E. McComas; Milton Thomas; H. J. Crow; and R. M. Town, laid out the town site. A contest was held to select a name for the new town with nurseryman Soloman Gates choosing the name of the Roman goddess of fruit and fruit trees, Pomona. Ten of the first streets of Pomona were named after the leaders and included Garey Avenue, Holt, Gordon Street, Thomas Street, and Gibbs Street, and ten were named after their wives, which included Eleanor, Imogene, Ellen, Rebecca, Bertie, Libbie, Elmira, and Louisa. Ellen is now Park Avenue; Elmira has been shortened to Elm Street; Elizabeth became Main Street; Imogene is now Linden Street; Bertie is San Francisco Avenue; and Louisa is now Locust Street; only Rebecca and Eleanor Streets retain their original names. The boundaries for the town consisted of Hamilton Street on the west, Holt Avenue on the north, Phillips Boulevard on the south, and Artesia Street (now named San Antonio Avenue) on the east.

The association advertised a land auction, which brought large crowds to Pomona. The crowds were met with flags flowing, a band, graded streets, and water flowing in open ditches next to the streets. It was only later that the purchasers of $18,000 worth of lots sold that day learned that the water had been temporarily diverted from the San Jose Creek. Unfortunately the Pomona Land and Water Company had taken a loan from the Temple and Workman Bank, which collapsed in 1876, leading to the failure of the water company and the end to their dream of the town of Pomona. Although the water company had failed, it was during this slow period in the development of Pomona that the first artesian well was dug in 1878. Soon other growers were digging other wells, and the agriculture of the area continued to prosper.

In 1882, Cyrus Mills and his wife, Susan, purchased much of the original land designated for the town site and vigorously promoted the town of Pomona. The first banking establishment, the Pomona Valley Bank, opened in 1884. In 1886, the Santa Fe Railroad was established through Pomona, as was the first fire department. By 1887, Pomona was thriving and well on its way to becoming the major agricultural center of Southern California. Efforts to incorporate began as early as 1884, but the first few attempts failed dismally because of the association of incorporation with temperance policy. In 1884, Pomona had one saloon for every 35 residents. By late 1887, conditions had improved, but public drunkenness still remained a problem. P. C. Tonner, who was concerned about the impact incorporation would have on the saloons, was determined that Pomona should remain wet with or without incorporation. However, on December 31, 1887, Tonner introduced the issue, which passed with a vote of more than four to one, transforming Pomona village into Pomona City.

An elected board of trustees, consisting of Chairman Charles French, C. E. White, John Johnson, James Harvey, and Franklin Cogswell, first governed Pomona. The first meeting of the trustees was on January 10, 1888, in the office of attorney F. D. Joy in the old Bates Block. After two meetings, space was rented for $10 per month in the McComas Building, located at 280–296 West Second Street. The first years of incorporation were very stormy with four different chairmen elected within a period of the first four months. It was not until 1892, under the leadership of John A. Gallup, that not a single resignation occurred for the full, four-year term. The governance by the board of trustees ceased on February 16, 1911, when a charter was adopted calling for four councilmen and a mayor.

In 1888, Pomona College was established in the rear of the Pilgrim Congregational Church. Later the college erected a building on the corner of White Avenue and Mission Boulevard.

The name Pomona proved to be prophetic, as vineyards flourished in the 1880s, supplying the wine making and raisin industries. In 1889, Charles Loop had a statue of the goddess made in Italy at a cost of $9,800. The statue was unveiled by Gen. John C. Fremont in 1890 and dedicated to the city. By the 1890s, citrus orchards and olive groves replaced the vineyards, and Pomona maintained an economic lead in the valley with its agricultural enterprises. By 1896, Pomona was such a thriving metropolis that Second Street was paved with asphalt for the first time.

Entrepreneurial leadership and innovation allowed Pomona to lead the valley in all major categories for many decades. The long-distance transmission of electricity, use of alternating current, the first semi-automatic switchboard west of the Mississippi, direct distance dialing, and

the first aluminum ladder all began in Pomona. The Pomona pump, which allowed liquids to be transported to the surface, is credited with preventing more starvation in the world than any other single device and was invented and manufactured in Pomona. The Pomona Pump Company's water-lubricated design later revolutionized deep well pumping.

The 1950s and 1960s brought many changes to Pomona, with the opening of the 10 Freeway; the construction of the underpasses on Towne and Garey Avenues; the conversion of the downtown to the pedestrian mall; the construction of the new civic center with the new city hall, public library, and council chambers; the construction of the County Superior Court Building; and the new shopping center on Indian Hill with Sears and Zody's as the anchor stores. Pomona was a major center for the aerospace industry. Slowly the Pomona economy began to decline with many businesses leaving the city, but its residents never lost their appreciation for the beautiful, unique homes and buildings located in all areas of the city, nor did the large city ever lose its small-town, neighborly flavor. A major effort was launched to preserve these buildings through the adoption of a historical ordinance by which individual buildings, homes, and neighborhoods could be designated, thereby assuring their protection and preservation.

Today the city of Pomona is a large multi-racial, multi-cultural city struggling to maintain its original grandeur and beauty through dedicated preservation efforts while striving to grow and develop an increased economic base. Pomona has three large historical districts and many individual historical landmarks. The first designated historical district, Lincoln Park, consisting of over 800 homes, is now on the National Register of Historical Places.

Although one of the oldest and largest cities in the Pomona Valley, Pomona is the youngest in terms of the average age of its residents and has the largest household size. Through the continued dedication, vision, innovation, and preservation of its residents, Pomona has again risen to a position of leadership, and once again its historic downtown is a thriving, bustling, leading commercial area with its trendy restaurants, shops, galleries, artists' lofts, and condos.

One

Adobes of Rancho San Jose

In 1837, when Ricardo Vejar and Ygnacio Palomares rode into the valley, they beheld a carpet of flowers of every hue covering the valley below. The foothills and the snow-capped mountains towered behind them to the north. Deer rested by the scattered clumps of trees that marked the many springs and streams, and rabbits ran in the grass. Marsh grass and cattails stood in muddy ponds over a wide swamp. The two friends must have been thrilled as they beheld the beauty of the land that was now theirs.

The rancho era, roughly from 1840 until 1860, saw the Rancho San Jose as the perfect example of California's Golden Age as food, money, and all necessities of life abounded, and large herds of cattle roamed across fenceless pastures. Palomares wrote before his death, "What do I want of gold? All these fertile leagues of land are mine. Every smoke you see rising is from the home of one of my children or one of my friends to whom I have given land."

In 1840, the two gentlemen were joined by Luis Arenas, who had married Palomares's sister, Josefa, and the governor granted a petition for a third square league of adjoining land on the west. Arenas either sold or lost his land to Henry Dalton in the early 1840s.

Ricardo Vejar became one of the wealthiest men in the area with some 13,000 acres of land and thousands of heads of cattle and horses. He owned two stores that supplied the other settlers. In the spring of 1861, two Los Angeles businessmen demanded prompt settlement of Vejar's account, for which he had mortgaged most of his ranch as security at a high interest rate. Vejar was unable to pay the more than $20,000 he owed, and the mortgage was foreclosed. Vejar and his family were forced to leave his princely estate of more than 10,000 acres of the best land in the world, which had been their home for many years.

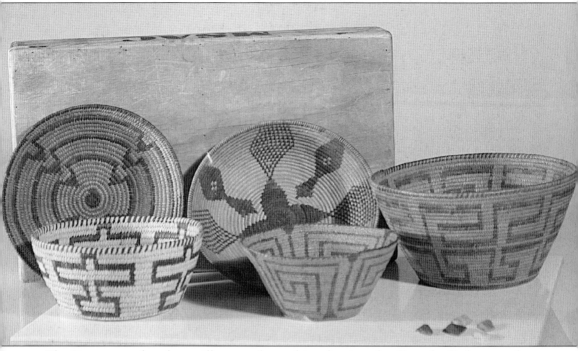

The Tongva people, whose village was located in what is today Ganesha Park, wove these baskets. The village was backed up against the Ganesha Hills to provide some protection from the elements. The arrowheads in the foreground are also relics of the Tongva people. The baskets are on display in the Mount San Antonio College Learning Center collection. (Courtesy William King, Ph.D.)

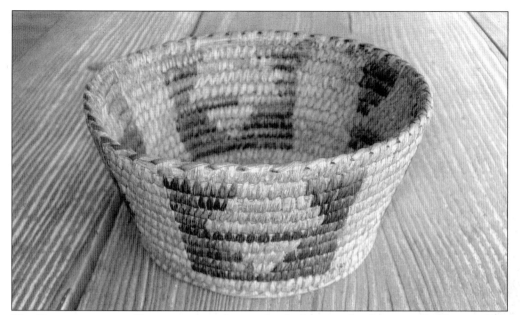

The Tongvas were excellent weavers and wove this basket so tight that it can hold water. The ladies of the Ricardo Vejar household used this basket to hold tobacco for rolling cigarettes. The basket is a part of the collections of the Historical Society of Pomona Valley and is on display at the Adobe de Palomares. (Photograph by Jim Gallivan.)

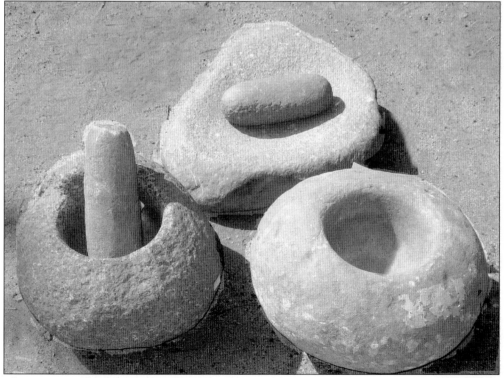

These stone *molcajetes* were used by the natives and belonged to the Ygnacio Palomares family. (Photograph by Jim Gallivan.)

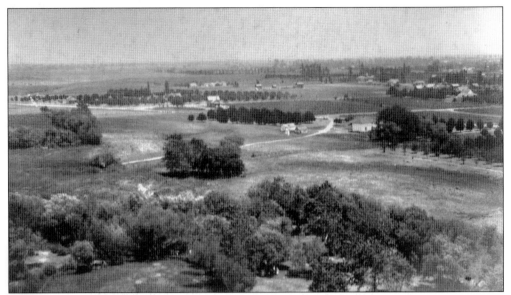

Under the oak tree in the very center of this photograph, the Palomares family, the Vejar family, and Padre Zalvideo gathered in 1837 to offer a mass of thanksgiving and blessing upon the families and their new possessions. In this early 1880s panorama looking southwest with Ganesha in the foreground, the historic Padre Oak is in the very center of the photograph. (Photograph by Frasher.)

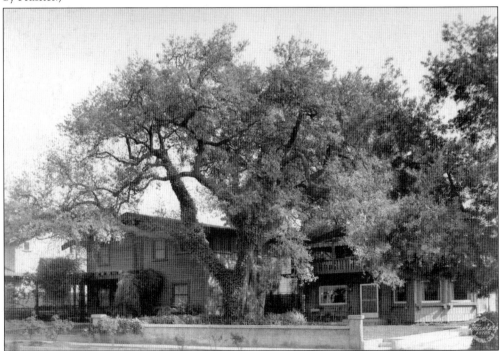

The Padre Oak, located at what is today 459 Kenoak Place, is believed to have been the stopping place of the mission fathers when they traveled through in 1832. It was under this tree on March 19, 1837, that the first Christian religious service in the Pomona Valley was held. Tomas Palomares built his adobe home on this site just north of the oak tree. (Courtesy Pomona Public Library.)

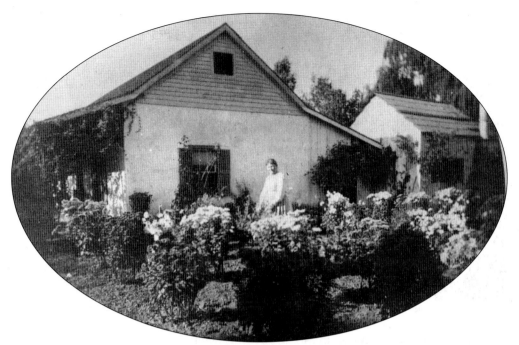

Located at 569 North Park Avenue, this 1837 adobe, known as Casa Primera, was the first residential dwelling in the Pomona Valley. Ygnacio Palomares and his family lived here for 17 years, until they moved to the 13-room Adobe de Palomares located on Arrow Highway. (Courtesy HSPV.)

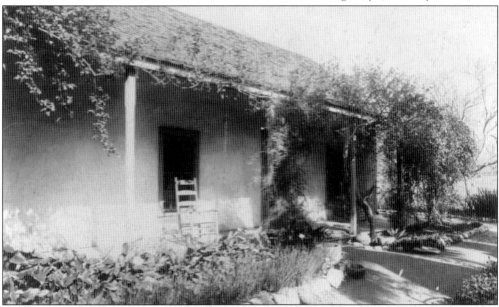

In 1867, Ygnacio's son, Francisco Palomares, and his wife, Dona Lugardo, returned to the home where they lived until Francisco's death in 1882. Much of the original water system, the *zonja*, is still visible. The beautiful gigantic fig tree, located directly behind the adobe, is over 100 years old. The home was privately owned by a succession of owners until 1973, when the Historical Society of Pomona Valley purchased it at a public auction. It has been completely restored to what is looked like in the late 1800s. (Courtesy Pomona Public Library.)

Ricardo Vejar first built a single-story adobe around a large, central courtyard near the banks of the Pedregoso Creek, on what are today the grounds of the Phillips Mansion at 2640 Pomona Boulevard. Louis Phillips and Esther Blake lived in the one-story adobe until 1875, when they built the mansion. Vejar later built an adobe in Walnut in which he spent his final years after losing much of his ranch. (Courtesy Pomona Public Library.)

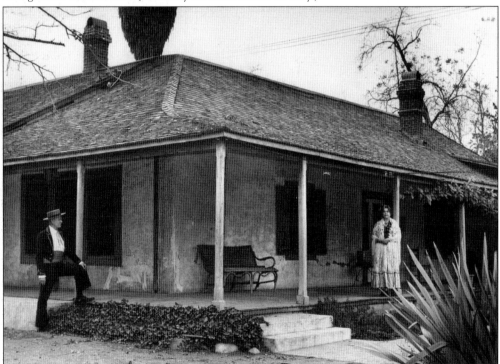

Built by Ygnacio Alvarado, the 1840 Casa Alvarado still serves as a private home. The 18-by-42-foot *sala* was used to celebrate mass and held many weddings of the founding families, often with 100 guests in attendance. The adobe was sold to Harry Storr around 1885 and a year later to Benjamin S. Nichols. The Fages family owned it until the mid-1990s, when it was sold to preservationists Bruce and Alana Coons. (Courtesy Pomona Public Library.)

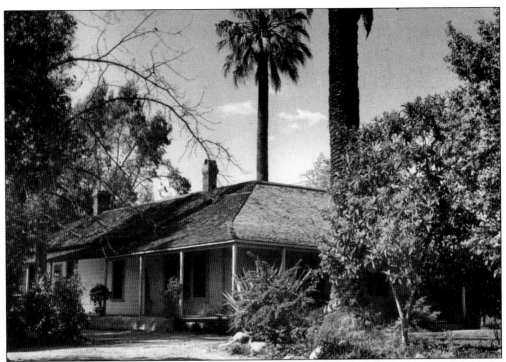

This building housed the first school in Pomona. The home has undergone considerable changes over the years as Victorian bedrooms replaced the adobe rooms, and a water tower and wooden bunkhouse were moved in order to complete the quadrangle of rooms around an open-center patio. (Courtesy Pomona Public Library.)

The Luis Arenas Adobe, built in 1840, was located on the corner of Gibbs and McKinley Avenues. It was built in 1840, when Luis Arenas, brother-in-law of Ygnacio Palomares, joined in the ownership of Rancho San Jose and was given an additional league of land. The home was demolished in 1909, but two of the trees in the above photograph still survive today, and until a few years ago, the adobe foundation was visible on the rear of property. (Courtesy Pomona Public Library.)

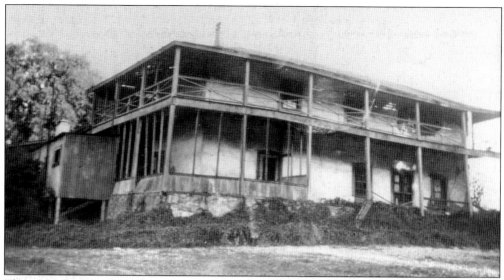

This 1944 photograph shows the large, two-story adobe home built by Ricardo Vejar as a wedding present for his son Ramon and his wife, Teresa Palomares Vejar, in 1855. The couple lived in the home until 1872. The home was located on the grounds of what is today Lanterman State Hospital and Developmental Center, approximately 200 feet from where the scale model sits today. It was one of the best of the adobes with its sturdy peon construction and a magnificent view of the valley. The adobe was torn down in 1955 to make room for new construction for the Developmental Center. Lanterman constructed and dedicated the scale model in memorial of the gracious old adobe. (Courtesy HSPV.)

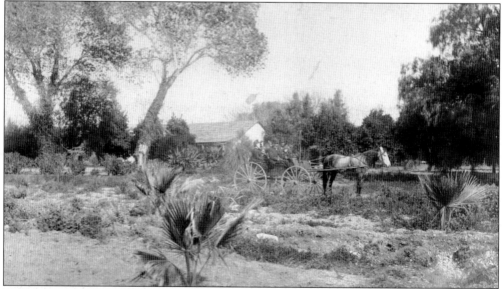

Designed in a T formation, this large, 13-room, one-story adobe was completed in 1855 for Ygnacio and Dona Chino Palomares. It was called La Casa de Madera (House of Wood) because of its roof of hand-split shakes and the wooden boards forming the floor of the *sala* and the guest and master bedrooms. In 1939, through a joint community effort, the home was authentically restored and furnished in accord with the style of the rancho period. Many of the articles of furnishings are precious heirlooms donated by descendants of the early families. (Courtesy HSPV.)

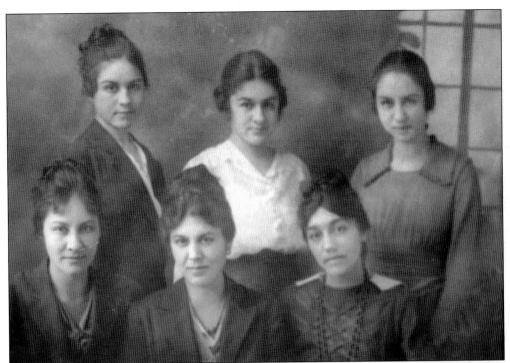

This is a photograph of the six daughters of Ygnacio and Conception Palomares: Teresa, Josefa, Carolina, Maria de Jesus, Christina, and Conception. (Courtesy Pomona Public Library.)

This photograph was taken when the adobe was a part of the Loop/Meserve holdings. Charles Loop purchased 160 acres surrounding the adobe in 1868 and planted orchards and vineyards. He and his family lived in it until they built a larger home. In 1873, Charles and his friend Alvin Meserve purchased an additional 220 acres on which they planted a variety of trees, including olive trees. Many of the olive trees still survive on the grounds today. (Courtesy HSPV.)

This photograph of the deserted Palomares Adobe was taken in 1895 and shows the neighborhood children in the foreground at the north end of the adobe. Mrs. F. D. Crank gave the photograph to the Historical Society of Pomona Valley. (Courtesy Pomona Public Library.)

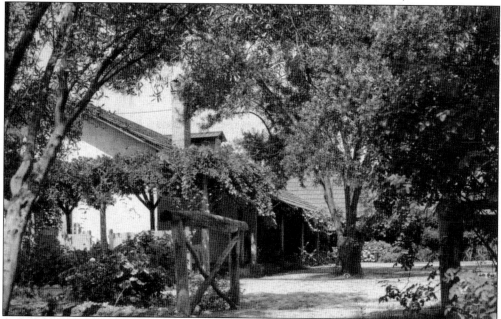

In the 1930s, the City of Pomona planned to raze the adobe and put in a water processing plant. The outcry from the community convinced the city the site should be saved and the adobe restored. Through the combined efforts of the Historical Society of Pomona Valley, the city, and WPA projects, the adobe was restored and opened to the public in 1940. The rooms are authentically furnished and contain many items from the original adobe. (Courtesy Gallivan family.)

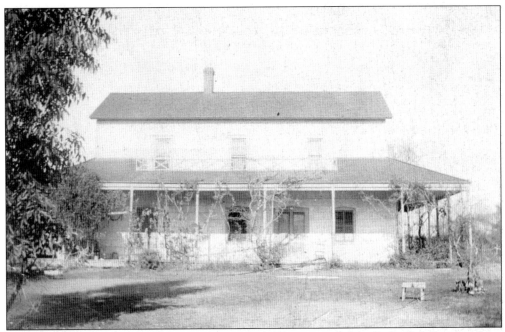

Tomas and Madelina Vejar de Palomares built this adobe just east of the Padre Oak. Josiah Alkine later purchased the adobe and added the second story. In 1902, at the time this photograph was taken, Josiah's widow lived in the home. The home was demolished when the Kenoak Tract was developed. (Courtesy HSPV.)

Ygnacio Palomares gave the land upon which this adobe sits to his nephew Saturino Carrion in 1843. The 340 rich, fertile acres were excellent grazing land for the herd of cattle Saturino had been grazing near the pueblo of Los Angeles. Saturino hired a noted Italian architect to design the adobe home in 1864, and the home was completed in 1868. In 1959, the local chapter of the Native Daughters of the Golden West dedicated the home as Historical Landmark No. 307 and placed a marker on it. Today the home is still a private residence, beautifully preserved and maintained by a young couple and their two sons. (Courtesy Pomona Public Library.)

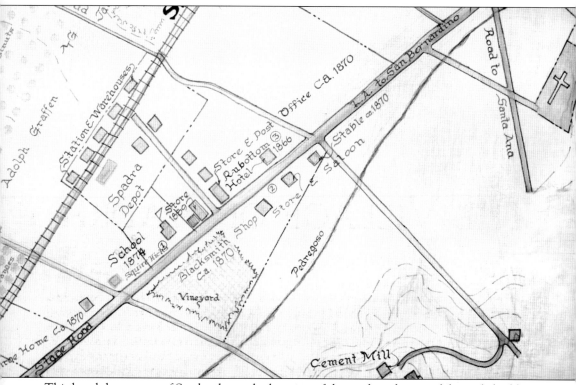

This hand-drawn map of Spadra shows the location of the roads and some of the early buildings in Spadra. (Courtesy HSPV.)

Two

THE VILLAGE OF SPADRA

In 1859, the Butterfield Stage began its southern route to Los Angeles through Rancho Santa Ana de Chino, along what is today Mission Boulevard and continuing along Holt Avenue, passing through what would become Spadra and Walnut, until it stopped in El Monte. In 1866, when Spadra was founded, Southern California was beginning a gradual transformation away from the Hispanic influence to the American influence. Although the Hispanic families remained in the area, the predominant population was natives of the South trying to escape the devastation of the Civil War. The Arnett family was the first Anglo family to settle in the area.

Several large farms were located in Spadra because it was a well-watered region with rich soil. The dependence on cattle had decreased and was replaced by raising wheat, hay, alfalfa, barley, and rye grains. French prunes and vineyards were also important, and citrus quickly became a staple for the area farmers. Although commerce declined with the extension of the railroad and the development of Pomona, agriculture in the Spadra area continues to survive in 2007, as it is home to the California State Polytechnic University, called "Cal Poly," which has a strong agricultural emphasis.

Once William Rubottom built his tavern, it immediately became a welcome stop for the Butterfield Stage. Rubottom's tavern is described as "setting a good table" and "being a welcome oasis." Spadra was centrally located, as it was the junction of the road coming south along the hills that handled traffic by way of Yuma from Kansas and the road that handled traffic over the Cajon Pass.

A school was founded almost immediately on the Phillips homesite, and later a building was constructed near the commercial area on what is today Temple Avenue and Pomona Boulevard. A Baptist church was also organized, first meeting in the school building and performing baptisms in a pond belonging to the Phillips. A hall was built near the railroad depot for dances and other social activities.

The first post office was established in the Phillips home on January 3, 1868, with Louis Phillips as postmaster. On April 28, 1870, when the new post office was officially opened in the hotel with Rubottom as postmaster, the official name of the community became Spadra. Spadra is an important part of the history of Pomona, as it was an important station on the transportation routes, its founding occurred during the transition period from the Hispanic influence to the more American influence, and it served as the precursor to Pomona.

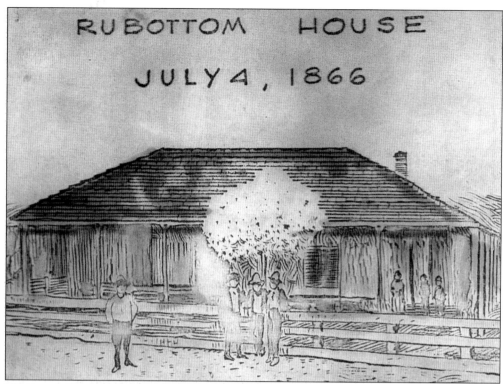

This is a drawing of the home built by William "Uncle Billy" Rubottom. The home also served as a lodge, hotel, and, at one time, the post office for the village of Spadra. It was an important stage station and was the social center for the entire area. In 1872, according to the *Los Angeles Star* newspaper, the hotel was a thriving business and was rated as having "the best boiled dinners in the State." It was located at what is today 3221 Pomona Boulevard. (Courtesy HSPV.)

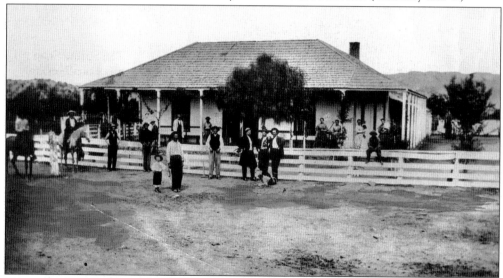

This early photograph of the Rubottom Hotel and Tavern, operated by Uncle Billy, shows guest and travelers outside the home in the 1860s. The home also served as a stage stop and post office. (Courtesy HSPV.)

Interested parents of Spadra formed the San Jose School District in 1867. The students first met on the Phillips homesite, and later a building was constructed. The Spadra School was located on the southeast corner of what is today Pomona Boulevard and Temple Avenue. After Spadra was annexed by Pomona, the Spadra School building was used to house students whose classrooms were being refurbished. (Courtesy HSPV.)

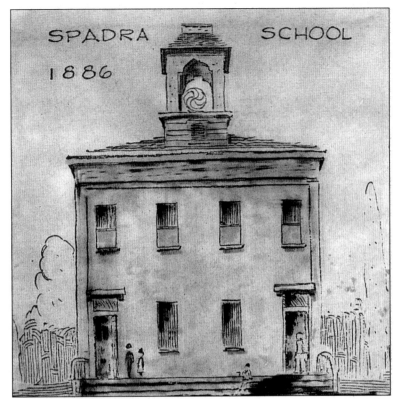

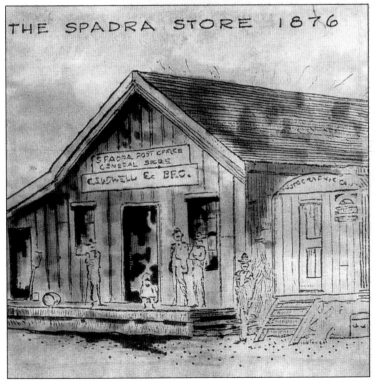

The Spadra Store was a small general store that served the residents of Spadra and surrounding area. It was developed by William Rubottom, the Reverend Richard Fryer, and several other members of the community. It was operated by George Eagon and was located at 3172 Pomona Boulevard. Another general store in Spadra was Caldwell and Brothers. (Courtesy HSPV.)

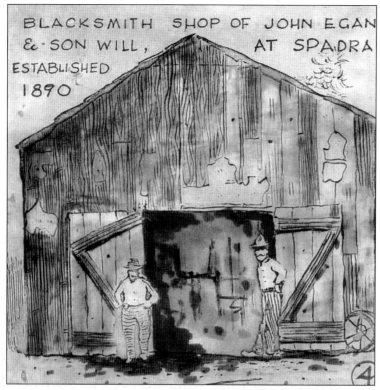

By 1870, Spadra could boast three stores, two blacksmith shops, warehouses for shipping via the railroad, a school, and a post office. This drawing is of the blacksmith shop owned by John Egan and his son. Egan was originally from Kentucky and was a staunch Democrat who loved to debate about politics. (Courtesy HSPV.)

Sarah Carter, affectionately called Stacy, owned and operated a mercantile store in the village of Spadra. Her home was an elegant Victorian and was frequently used for weddings and other celebrations. On May 3, 1905, Pearl Scott, age 19, married William Hopp, age 30, in this home. On October 9, 1909, Pearl was fatally shot by her lover, Lee Warner, who then fatally wounded himself. The young couple was found under a peach tree near the home of Pearl's father after her father and neighbors heard two shots. (Courtesy HSPV.)

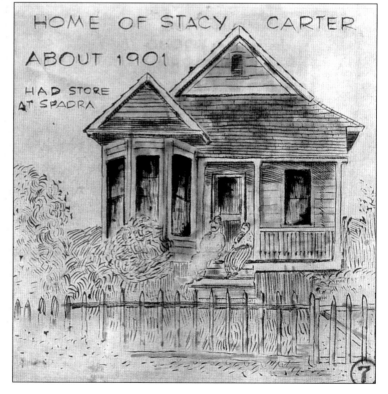

This is a drawing of the home of Richard C. Fryer, an ordained Baptist minister who originally came from Alabama to settle in El Monte and establish a church. The Reverend Fryer was elected to the Los Angeles County Board of Supervisors in 1857 and served in the assembly from 1870 to 1871. He moved to Spadra in 1867, where he again established a new church that eventually became the First Baptist Church of Pomona. His son, James M. Fryer, is considered to be the father of the Pomona School System. Later Mrs. J. G. Biller lived in the home. It was located at 3041 Pomona Boulevard. (Courtesy HSPV.)

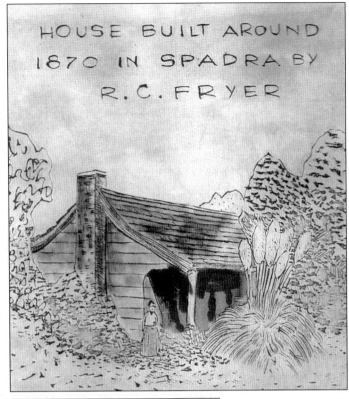

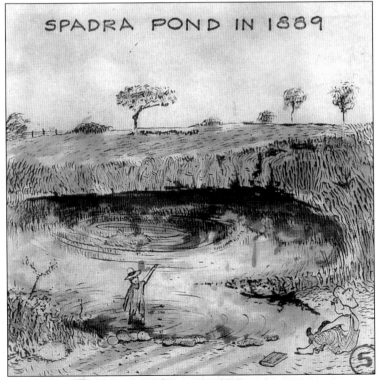

The Reverend Richard Fryer used the Spadra Pond, located on the Phillips property, to baptize new members of the church. The location of the pond is in what is today the City of Diamond Bar and was filled during the 1960s to make room for a new housing development. (Courtesy HSPV.)

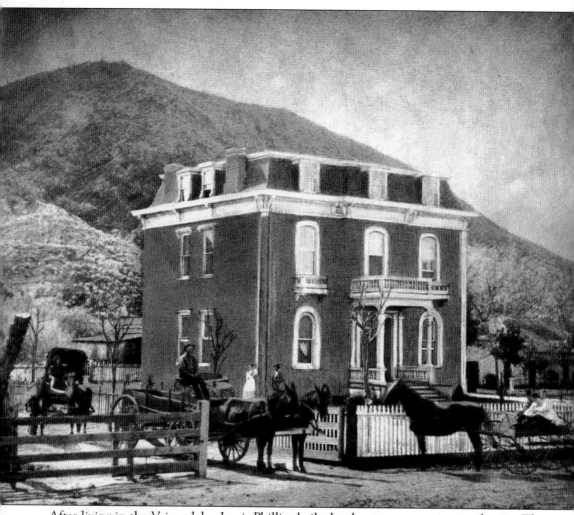

After living in the Vejar adobe, Louis Phillips built the three-story mansion on the site. The Second Empire (Napoleon III) building was the first brick building in the area. The mansion was converted into apartments during World War II. The Historical Society of Pomona Valley purchased the building in 1966 and began restoration. The building was heavily damaged in the earthquakes of the 1990s. The Historical Society of Pomona Valley has been working on its restoration for many years. (Courtesy HSPV.)

The Louis Phillips family is buried in the Spadra Cemetery with this beautiful monument marking their burial spot. In addition to the marker, other tributes to Louis Phillips include Phillips Boulevard and the Phillips Ranch Development. (Courtesy HSPV.)

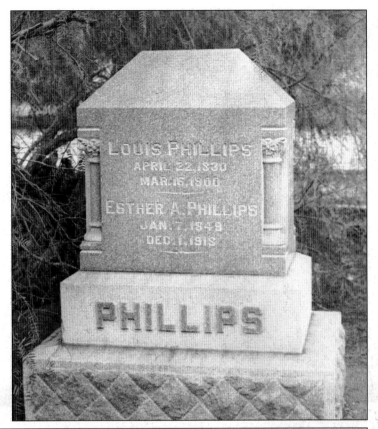

This postcard was mailed to Mrs. S. E. Hicks in Spadra in 1910. Several Hicks families owned farms in Spadra. (Courtesy HSPV.)

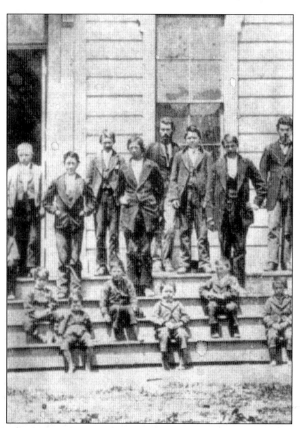

The Spadra School was located on what is today Pomona Boulevard and Temple Avenue near present-day Cal Poly. As late as the 1950s, it was still used occasionally for classes when space was limited. (Courtesy HSPV.)

This 1881 map of California shows both Spadra and Pomona, although it was made seven years before Pomona was incorporated. The extension of the railroad and the development of Pomona eventually led to the demise of Spadra. (Courtesy Gallivan family.)

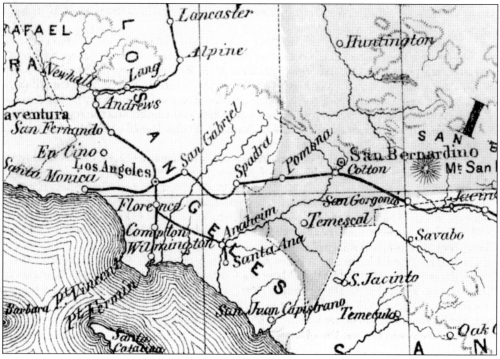

Three

THE CENTER OF THE VALLEY

After incorporation, Pomona organized a board of trade to function as the city booster. Early leaders were Stoddard Jess, Phil Stein, J. T. Brady, J. D. H. Browne, Rev. C. F. Loop, J. E. Packard, John Wasson, Fred J. Smith, J. A. Dole, S. M. Haskell, D. R. Knull, D. C. Teague, J. W. Thomas, and R. K. Pitzer. Around 1891, the board arranged for a stage to run three times per day between Pomona and Chino. In 1893, the board distributed 20,000 lithographed pamphlets at the Columbian Exposition in Chicago and in 1894 had an exhibit. The board secured a right-of-way from Southern Pacific's main line through Chino to the city limits of Pomona and an electric railway between Claremont and Pomona. The board advocated for fruit inspection in an effort to fight the Mediterranean fruit fly. Around 1912, the Pomona Board of Trade transferred its duties to the new Pomona Chamber of Commerce.

According to the January 29, 1887, issue of the *Times-Courier*, businesses in Pomona included the Boston Boot and Shoe House; Loucks bookseller and stationer; Bassetts Agency, which sold real estate and pianos, organs, and sewing machines; C. R. Woodburry, who sold cook stoves; and E. T. Palmer, which advertised gift items with Pomona views on each. Both King's and Brown's Hotel offered single meals. The Central Shaving Parlor advertised hot and cold baths every day. The five attorneys were Sumner, Joy, Tonner, Claiborne, and Clarke, and the seven physicians were Brown, Coates, Howe and Crank, Von Bonhorst, Dunn, Daniels, and Murphy. James T. Taylor was the only civil engineer in Pomona.

Other early businesses included Pomona Feed Store, Tackaberry Druggist, Caldwell Druggist, Pomona Land Bureau, Strong and Lorbeer furniture, Pomona Nursery, Kerckhoff-Cuzner Mill and Lumber Company, the People's Market, the People's Store, Goodwin Furniture, Pomona Brick Yard, W. D. Smith Wagon Maker, E. B. Smith Blacksmith, Opera Shaving Parlor, Finson's Pomona Express, Machada and Bridger Livery Stable, A. L. Taylor House Moving, Mrs. Buck's Millinery, J. M. Armour Ranch Implements, Boston Feed Store, Pomona Bakery, First National Bank, Pomona Bank, and numerous others.

The first hotel, at Fifth Street and Garey Avenue, was built by M. A. Marshall. In 1884, Brown's Hotel, known as the Pacific Hotel and later the Commercial, was located at 465 West Second Street. It was demolished in 1919. Western Hotel on Garey between Fourth Street and Mission Boulevard was built in 1887 by Isham Fuqua and boasted 30 rooms. Kings Hotel was built in 1888 by Louis Brosseau and was located on South Main Street between Third and Fourth Streets. The king of all the hotels was the Palomares Hotel.

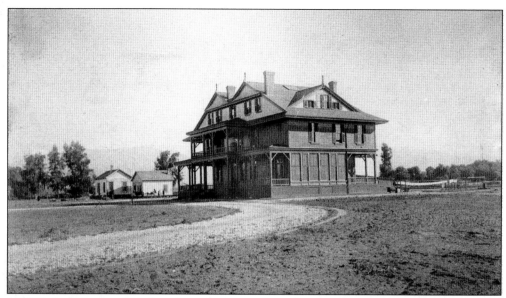

In 1885, the Palomares Hotel was being built near the railroad tracks, where the YMCA is located in 2007. The hotel was built by the Pomona Land and Water Company and originally had 30 rooms. (Courtesy HSPV.)

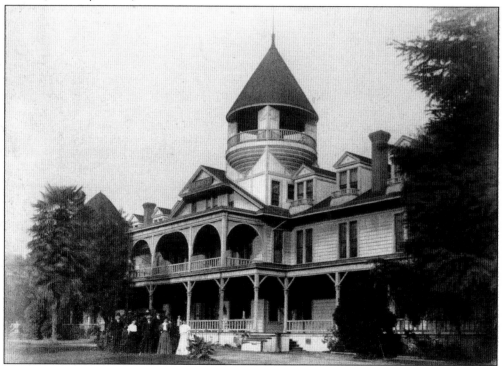

In 1887, the Palomares Hotel was taken over by a syndicate of Pomona men. It was moved to one side and enlarged to 132 rooms. The three-story structure was adorned by a large cupola and a wide veranda across the front. Frank Miller, the first manager hired, later became famous as the manager of the Mission Inn in Riverside. The hotel was destroyed by fire in 1911. (Courtesy HSPV.)

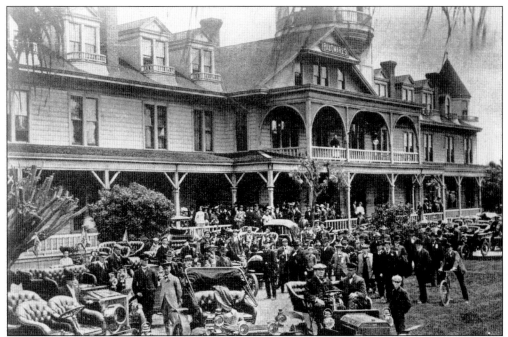

Automobile Club members pose in front of the Palomares Hotel on April 27, 1904, when the hotel was the destination for the club's first annual run. Forty-two vehicles and the county sheriff and supervisors participated in the run. The hotel was the center of the social life of the community and the scene of many gatherings. (Courtesy HSPV.)

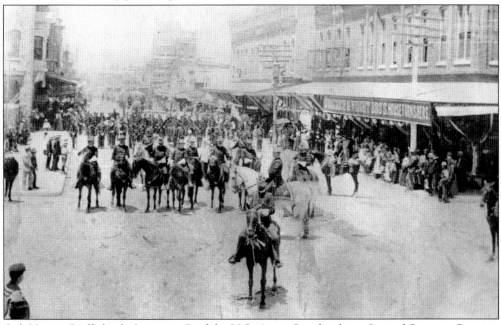

Col. Homer Duffy leads Company D of the U.S. Army Cavalry down Second Street in Pomona in 1895. Most of the residents of Pomona turned out to witness the sight. The Wright Brothers furniture store can be seen in the background. They were involved in the furniture business in Pomona until 1977. (Courtesy HSPV.)

Los Angeles County records show that Mr. and Mrs. George W. Farmington were the first couple married in Pomona on October 6, 1876. This photograph was taken in celebration of their 20th wedding anniversary on October 5, 1896, by photographer Schwichtenberg. Many photographs of the early residents of Pomona were taken by Schwichtenberg's Studio, which was located next to the Pomona Post Office. (Courtesy Gallivan family.)

A large group of young ladies and their chaperons gathered in their carriages on Second Street to begin their annual trip to the foothills for a picnic. The young women in the photograph whose names are known are Lizzie West, Denise Rowland, Ollie Burke, Ona Cameron, Daisy Hamilton, Hallie Atkinson, Fannie Bagley, and Lula Wofford. (Courtesy HSPV.)

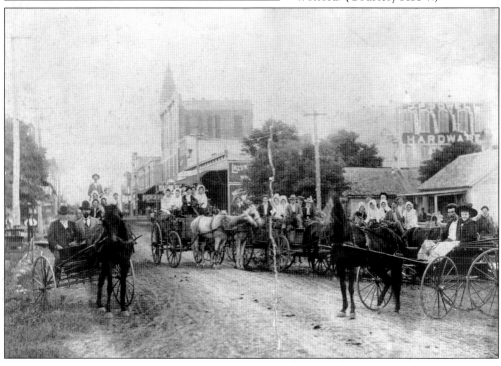

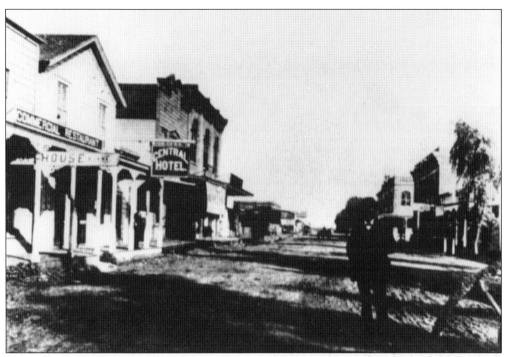

Constable Frank Slanker walks down Second Street in the late 1880s. He was the first law officer in Pomona and served from 1887 until his death in 1932. He had the reputation for being so tough that criminals would give up once they knew he was on their trail. He could also solve crimes with a few well-chosen words. (Courtesy HSPV.)

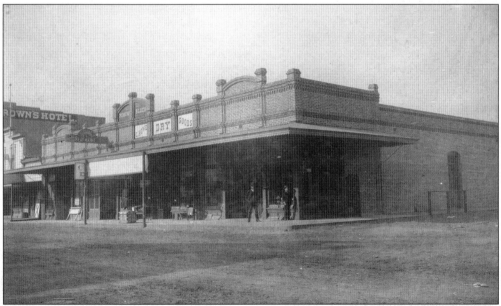

Brown's Hotel, built in 1884, was one of the first hotels in Pomona and was originally called the Pacific Hotel, and later the Commercial. It was located at Second Street, one block west of Gordon Street. The hotel was demolished in 1919. The photograph was donated to the Historical Society of Pomona Valley by Linda S. Schuraman. (Courtesy HSPV.)

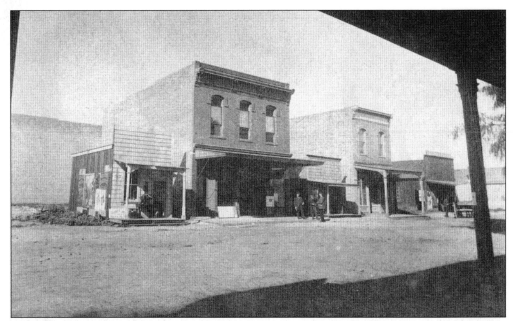

This early photograph of Second Street was taken prior to 1888 and shows two redbrick buildings of the classical architectural style for which Second Street became known. Many of the early buildings of this style still survive today, and the slightly arched windows are still visible from the alleys. The street is dirt, as Second Street was not paved until 1896. One of the buildings was a cabaret. Pomona was well known for the large number of saloons and bars. (Courtesy HSPV.)

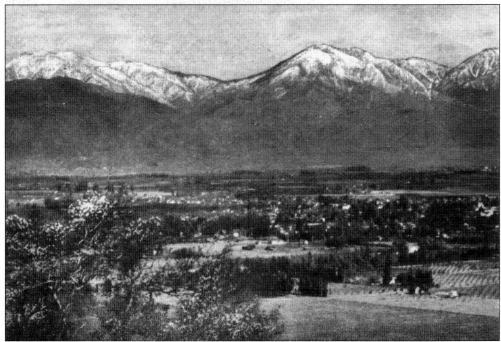

This early photographic view of Ole Baldy Mountain and bird's-eye view of Pomona was taken from the hills to the south of present-day Pomona. The photograph shows very few buildings and considerable agriculture. (Courtesy HSPV.)

The Choral Union, made up of singers from the various churches, was organized in 1888 and directed by Prof. Frank Parkhurst Brackett of Pomona College. One of the performances it gave each year was the Fruit and Flower Mission at Ye Olde Pomona Opera House. The performers in this 1888 rendition were Brownie Clarke, Bessie Lamb, Agnes Denison, Beatrice Overton, Mamie Carson, Margaret Logarr, Bert Wanigan, W. Elyruer, Belle Topliff (Stein), Rebecca Belcher, Clara Mueller, Edith Blades, Bessie Mason, Della Overton, and Walter De Lewis. (Courtesy HSPV.)

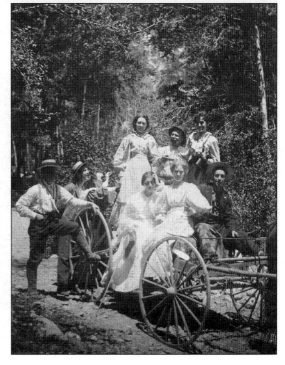

Mae Douglas Miller is the young lady sitting closest to the horse. She grew up in Pomona and was the mother of Douglas Clinton Miller, who was a prominent local businessman. The Douglas Clinton Miller family had a home on Park Avenue. (Courtesy HSPV; donated by Jean Amodt.)

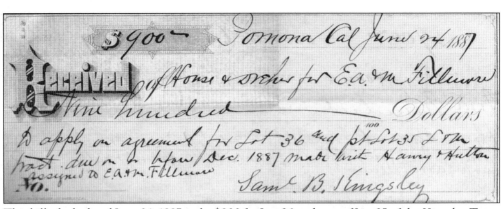

This bill of sale dated June 24, 1887, is for $900 for Lot 36 and part of Lot 35 of the Kingsley Tract. The money is partial settlement of the agreement made with Harry Huttom for E. M. Filmore. The receipt is signed by Sam B. Kingsley. The Kingsley Tract was east of Towne Avenue and west of Holt Avenue. (Courtesy Gallivan family.)

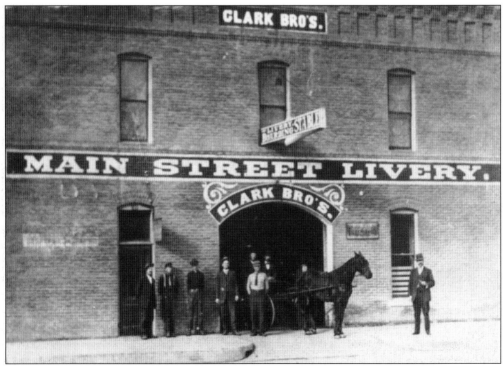

Clark Brothers Livery was one of the early businesses of Pomona located on West Second Street. It was best known for its jitney services, which provided group excursions to neighboring communities. Once the automobile became popular, the business was modernized and became Clark Brothers Garage. (Courtesy HSPV.)

This 1885 photograph of the northwest corner of Second and Thomas Streets shows mostly adobe and wood-framed buildings. The earliest brick buildings in Pomona were east of Garey Avenue. (Courtesy HSPV.)

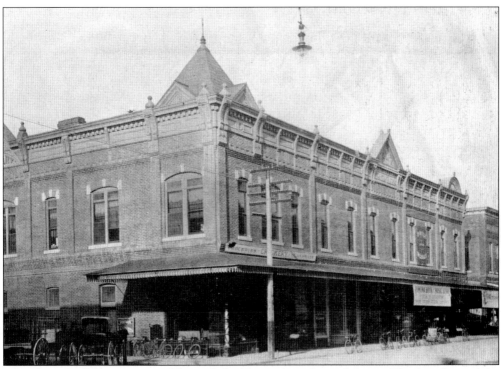

This photograph shows some of the early buildings along Second Street. The first floor of the buildings housed businesses, with one of the businesses in the photograph advertising groceries, crockery, and glassware. The upper stories were a hotel, and guests could get either daily or weekly rates. (Courtesy HSPV.)

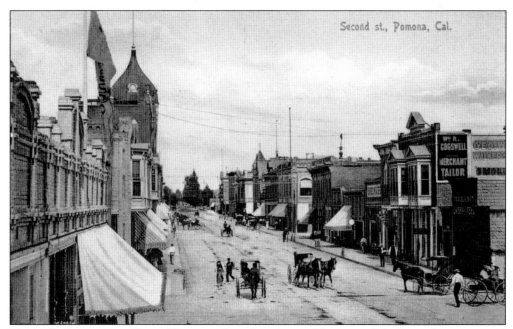

This early photograph of Second Street predates the advent of the automobile. It was the commercial and businesses center of Pomona and of the entire Pomona Valley. The beautiful redbrick buildings are classical-style architecture with strong lines. (Courtesy HSPV.)

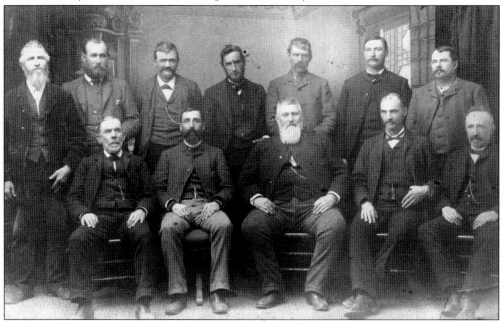

The first board of trustees was elected shortly after Pomona was incorporated in 1888. The members of the first board were, from left to right, (first row) C. E. White, Chairman Charles French, Judge and city recorder J. A. Clarke, first city attorney F. D. Joy, and John Johnston; (second row) night watchman E. M. Scriminger, city engineer James T. Taylor, James Harvey, Franklin Cogswell, marshall M. J. Smith, city clerk Arza Crabb, and street superintendent Ben Atkinson. (Courtesy Pomona Public Library.)

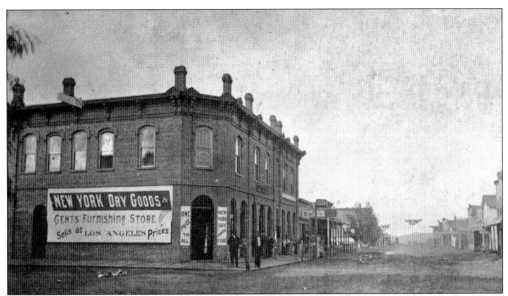

This building was built in 1924 by the New York Dry Goods Store and replaced an older building, which was torn down. The older building once housed the Gerrard Market, who later went on to found the Alpha Beta Stores. The New York Dry Goods Store was in business here for many years. (Courtesy HSPV.)

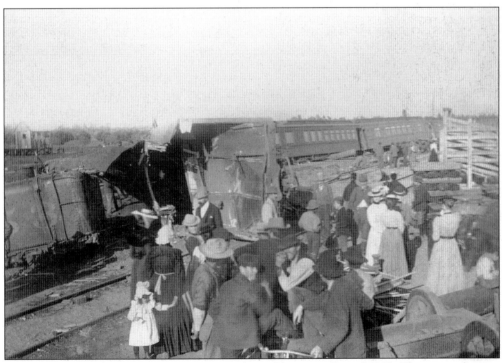

This photograph shows the tragic train wreck on Christmas Eve of 1899. Thirty people were killed or injured and had to be treated in private homes before they could be transported to Los Angles. It strained Pomona's limited medical resources so greatly that it led to the creation of the first hospital in Pomona. (Courtesy HSPV.)

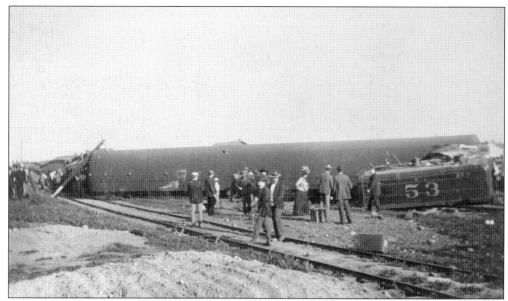

Many of the cars were completely derailed, and several were turned upside down. Eliza Bradury organized a committee to take action to develop a facility to provide emergency medical care. (Courtesy HSPV.)

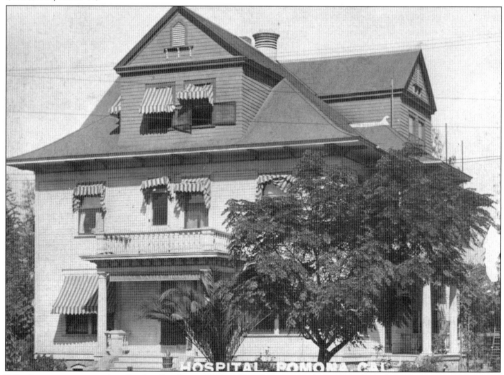

The committee, under the leadership of Eliza Bradury, raised the funds to build the first hospital in Pomona. Completed in 1903, the two-and-a-half-story building had 12 patient rooms, an operating room, and living quarters for nurses. The Nurses' Training School was affiliated with the hospital for over 25 years. (Courtesy Pomona Public Library.)

This home was owned by John F. and Jane Smith Frisbee of Pomona. The Frisbees were the grandparents of Louisa Fisk, who was born in the Palomares Hotel, where her father was the manager. (Courtesy HSPV; donated by Selters family.)

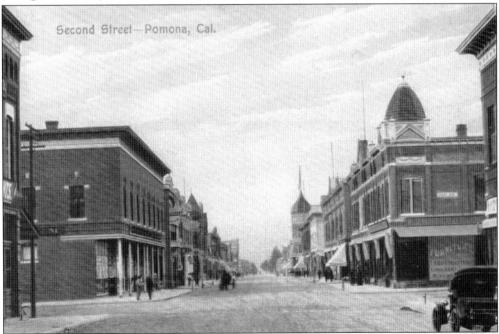

The above photograph shows Second Street looking west from Garey Avenue around 1905. During this era, Second Street was still the commercial business center of the valley. Some of the horse-drawn wagons have been replaced by the horseless carriages. The bank building, with its dome towers, can be seen on the right. (Courtesy HSPV.)

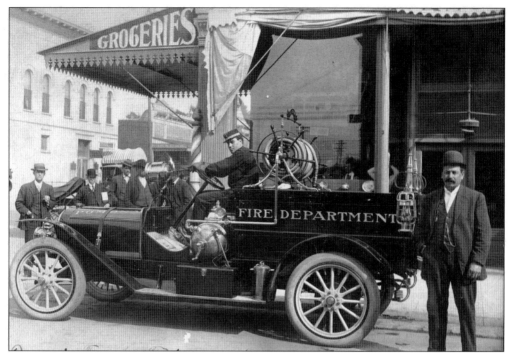

The volunteer hose company was started in the Pomona area in September 1883. The company is shown with the first Pomona fire truck on the corner of Main and First Streets in 1889. In the early 1900s, the first fire station was built at this same location. Veteran's Hall now occupies this location. (Courtesy HSPV; donated by Margaret Lorbeer in 1944.)

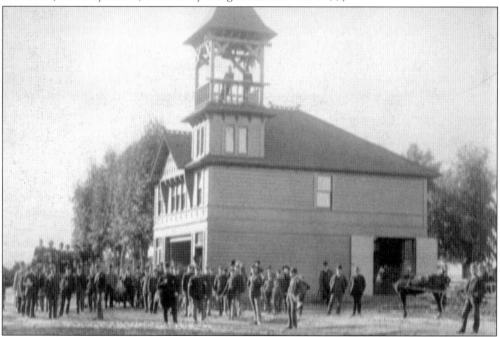

This early fire station was built in the early 1900s and was located on the corner of Main and First Streets. (Courtesy HSPV.)

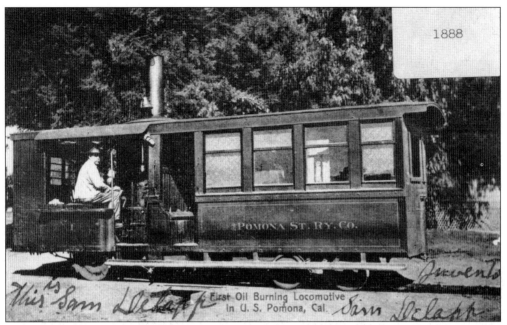

Pictured above is one of the Big Red cars, the line of the Pacific Electric Railroad that served Pomona for 60 years. (Courtesy of Pomona Public Library.)

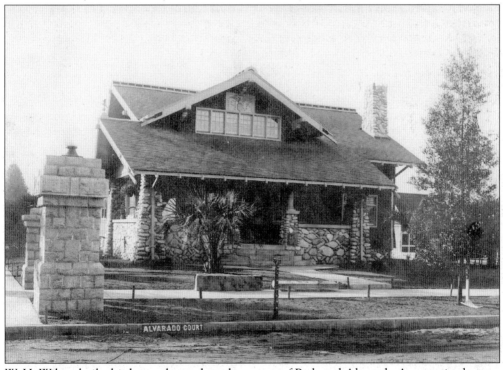

W. H. Wilton built this home, located on the corner of Park and Alvarado Avenues in the area now designated as the Wilton Heights Historical District, for himself. Wilton was a major builder in Pomona, constructing several of the buildings that are designated historical landmarks today. (Courtesy HSPV.)

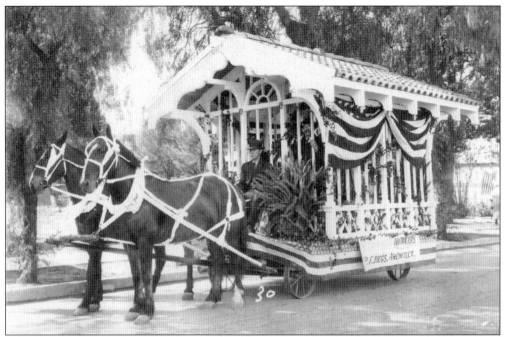

This beautiful bird aviary is located in the back of the Wilton home and faces Park Avenue. Wilton placed the aviary on a wagon pulled by a team of horses and entered it in the Rose Parade to advertise his business and that of a colleague who was an architect in about 1915. This photograph of the aviary was taken on Colorado Boulevard in Pasadena. (Courtesy HSPV.)

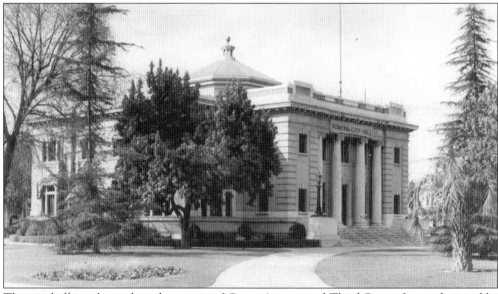

The city hall was located on the corner of Garey Avenue and Third Street. It was designed by J. A. Park and built at a total cost of $40,000, including furnishings. The Pomona Board of Trade handled the bond issue campaign, which had popular support. This photograph was taken in April 1955. J. A. Park went on to become a renowned architect in New York City. The building was demolished in 1968 to make way for the Bank of California building. (Courtesy Pomona Public Library.)

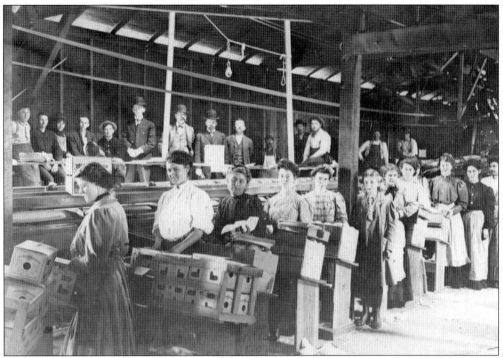

This 1906 photograph shows a Pomona packinghouse for oranges and lemons. Many young women worked in the houses. The fifth young woman from the right in the first row is Birdie M. Ades. (Courtesy HSPV.)

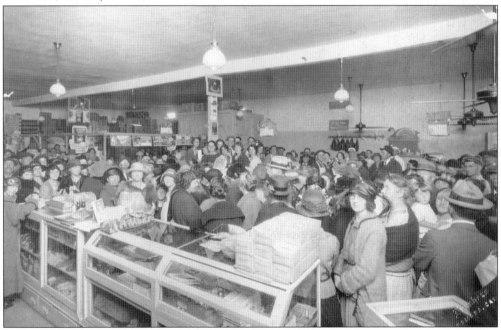

This store was located on the southwest corner of East Second Street and Towne Avenue. It later became one of the three Torleys' Markets in Pomona. There is definitely not a shortage of customers. (Courtesy HSPV.)

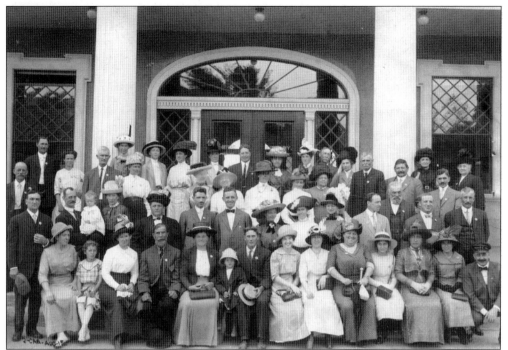

For many years, the Historical Society of Pomona Valley organized an annual trip to a place of historical interest. The trips were eagerly awaited each year and were very popular. This photograph, taken by C. E. McCarthy, excursion photographer, is a souvenir of the Balloon Route Trolley Trip to Los Angeles and was taken on the library steps of the National Soldiers Home. (Courtesy HSPV.)

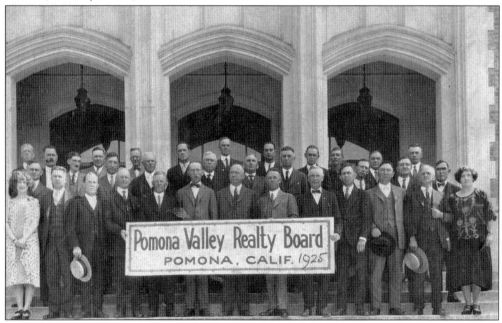

The members of the Pomona Board of Reality are standing on the steps of the Pomona City Hall in 1925. It is interesting to note that two members of the board are women. (Courtesy HSPV.)

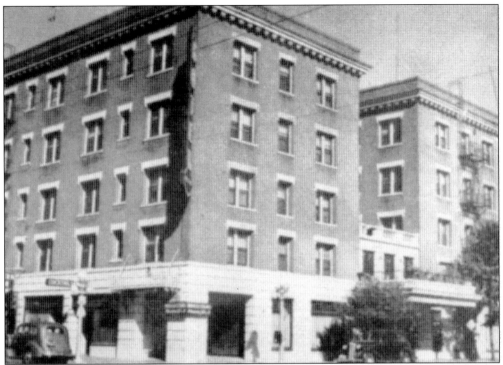

W. M. Avis built the 65-room Avis Hotel in 1915 at the northeast corner of Third Street and Garey Avenue. In 1927, the hotel changed ownership and was renamed the Edgar, and in 1932, the five-story hotel became the Mayfair, the name it bears today. The building is currently undergoing restoration and remodeling to house condominiums. (Courtesy HSPV.)

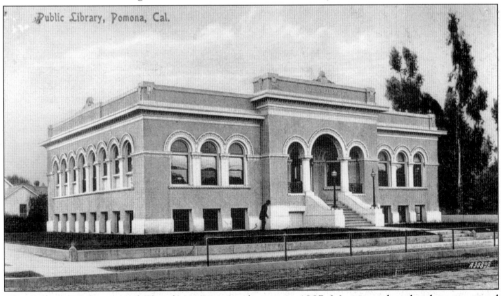

The Pomona Library and Floral Association began in 1887. Money to buy books was raised through contributions, memberships, and flower festivals. The city first rented space in the First National Bank to house the books. The Carnegie Library was begun in 1902 and completed in 1903. When it became too small, an addition was completed in 1913. (Courtesy HSPV.)

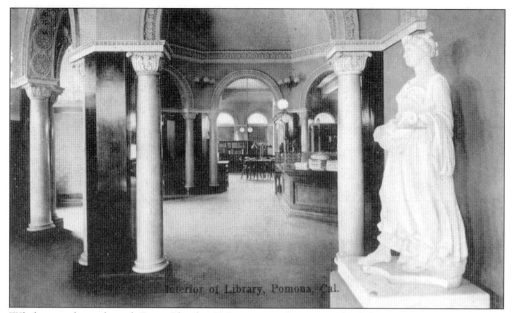

While traveling abroad, Rev. Charles F. Loop saw the original of the statue of the Goddess Pomona in the Uffizi Gallery in Florence. He was very impressed with the beauty of the statue and its symbolic worth to his own city of Pomona. He arranged for a replica by the Italian artist Antonio Frilli to be made and presented it to the City of Pomona in 1889. A special room was built for the statue in the Carnegie Library. (Courtesy HSPV.)

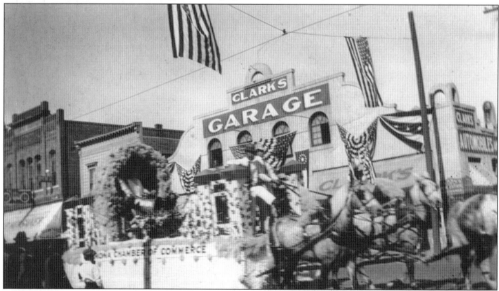

This photograph shows the 1913 parade on West Second Street in front of Clark's Garage, which was built in 1910 and located at 501 West Second Street. Leria Slanker Clark ran the business, which was best known for its jitney service. By 1918, the business was the Pomona Garage and sold Marmon and Peerless Motor Cars and Moreland Trucks. In 1958, Montgomery Ward opened a sales and service annex in the building. This mission-style building maintains much of its original charm. The four metal, arched windows above the show room window have been covered up but are still in place. (Courtesy Kennedy family.)

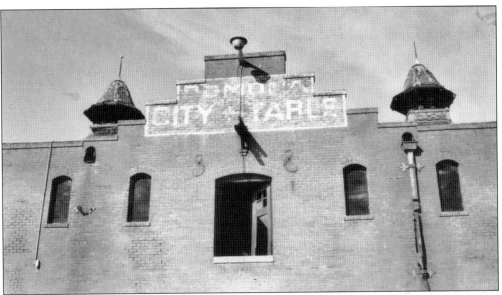

The City Stables, located at 636 West Monterrey Avenue, were constructed in 1909 at a cost of $5,641. The stables housed 26 horses for the growing city. After only 28 years of service, the City Stables were closed in 1937, as all of the horses had been replaced by motorized trucks. The sign reading "City Stables" was painted over with "City Yard," and the building was used as a warehouse for civil defense emergency equipment until it was condemned in the early 1970s. The building is on the National Registry of Historical Places. (Courtesy HSPV.)

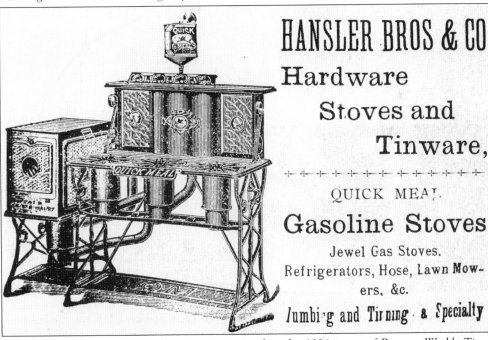

An advertisement for this gasoline stove appeared in the 1884 issues of *Pomona Weekly Times*. The stove was available at Hansler Brothers and Company. By 1895, over 100 patents had been issued for gasoline stoves. Many people were killed when the stoves exploded or caught on fire. (Courtesy HSPV.)

This advertisement for the Red Dragon Paint Store on Second Street appeared in the 1884 *Pomona Weekly Times*. (Courtesy HSPV.)

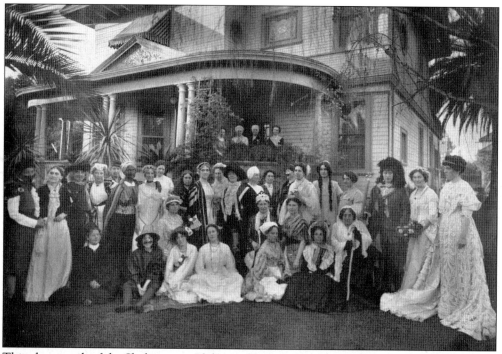

This photograph of the Shakespeare Club was taken on February 18, 1912, in front of the porch of Mrs. George S. (Irene) Phillips's home. The home was located on the corner of Holt Avenue and Palomares Street. The ladies are dressed in costume, as the club was observing Character Day. (Courtesy HSPV; donated by Pomona Ebell Club.)

This advertisement appeared in the 1894 *Pomona Weekly Times*. When Walter B. Todd came to Pomona in 1905, he first engaged in the undertaking business on Second Street with J. E. Patterson. (Courtesy HSPV.)

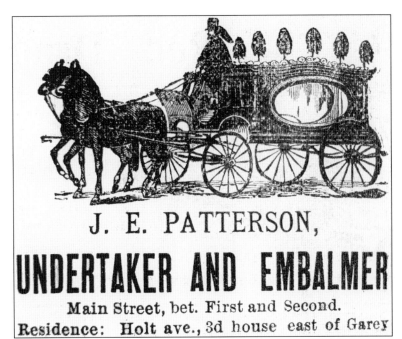

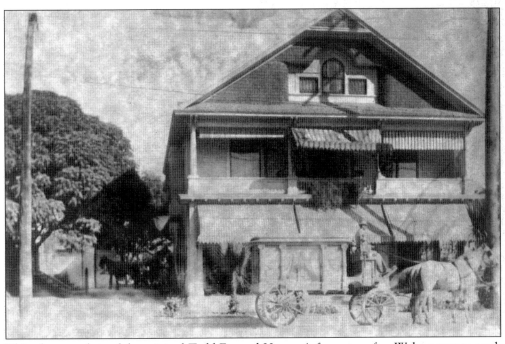

This photograph is of the original Todd Funeral Home. A few years after Walter went to work for Patterson, he started his own undertaking business. In 1914, Todd formed a partnership with Tillman W. Patterson under the name of Todd and Patterson. (Courtesy Todd Mortuary.)

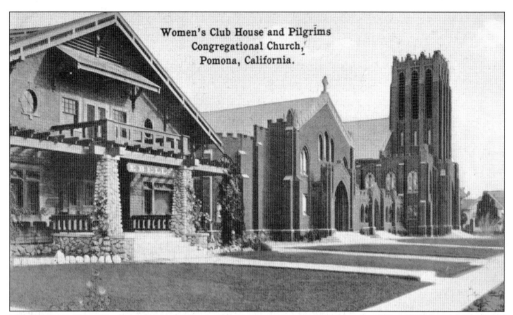

The Pomona Ebell building was built on the corner of Garey Avenue and Pearl Street next to the Pilgrim Congregational Church. The building was dedicated on October 13, 1910, and consisted of a reception hall, parlor, dining room, and kitchen. It was designed by prominent local Lincoln Park architect Ferdinand Davis after the Shakespeare Club house in Pasadena. The total cost for the building and grounds was $11,000. (Courtesy Pomona Public Library.)

The original Ebell building was moved to Holt and Caswell Avenues in 1922, and the construction of the large, two-story auditorium was completed in 1924. World-renowned singers and musicians performed in the auditorium, including Joey Brown, Will Rogers, Maria Callas, and Efren Zimbalist Sr. Richard Nixon first announced his candidacy for president against John F. Kennedy on the stage of the Ebell. (Courtesy Pomona Public Library.)

This camphor, planted by John E. Packard in 1883, was on the property where the Ebell building was moved. The tree was the largest camphor in the world, with a height of 45 feet and a spread of 90 feet. A photograph of the tree is in the Library of Congress. The tree became diseased, and after numerous efforts to save it failed, it was removed in 1978. (Courtesy Pomona Public Library.)

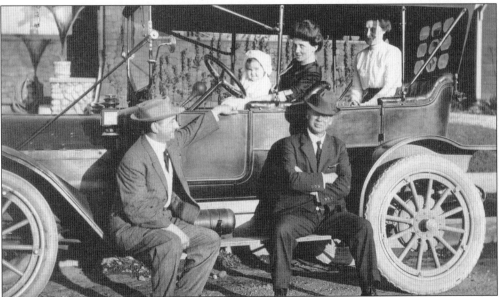

This photograph shows Maud Kaltenbeck Fisk holding daughter Louisa F. Fisk. The man on the left is Montgomery S. Fisk, father of Louisa and husband of Maud. He was the manager of the Palomares Hotel. Louisa was born in the Palomares Hotel. Louisa and her husband lived in the home on Eleanor where she grew up until his death. She continued to live there until she became incapacitated. She died about 2006. (Courtesy HSPV; donated by Selters family.)

This photograph shows Edwina Fratzke with her parents when she was about eight years old. Edwina grew up in the Lincoln Park area and graduated from Pomona High School in 1932. Although she was pretty and popular, she was never married or employed. Like many other women of this era, she lived with and took care of her parents until their deaths. (Courtesy HSPV; donated by Van Allen family.)

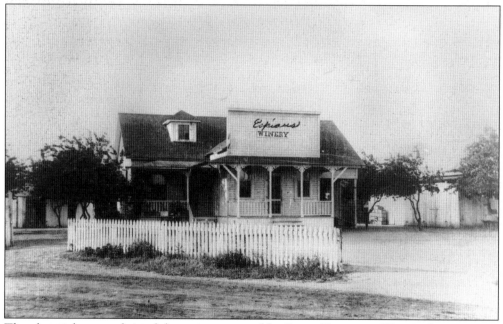

The above photograph is of the winery opened by Pierre Espiau on West Holt Avenue in Pomona in the early 1900s. He was a very successful wine maker. (Courtesy HSPV; donated by Espiau family.)

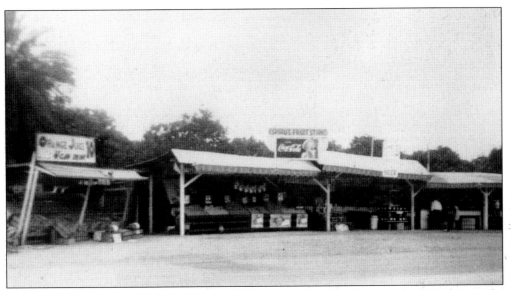

Pierre Espiau opened a saloon on First Street shortly after coming to Pomona. He raised grapes for his winery and oranges and other fruit that he sold at his fruit stand on West Holt Avenue. When beer became legal again in 1933 after Prohibition, Wilbur Espiau took over his father's fruit stand to sell beer, sandwiches, and light groceries. He was soon offering tacos and enchiladas. Traffic was heavy on Holt Avenue, as it was the main route between Los Angeles and San Bernardino and Palm Springs. The business, Espiau's Restaurant, went on to be rated as one of the top 500 restaurants in the nation by the *National Restaurant Hospitality* magazine. (Courtesy HSPV; donated by Espiau family.)

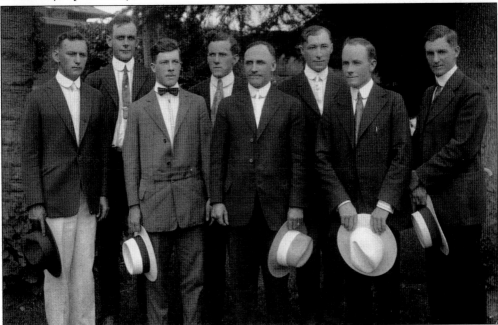

This photograph shows the staff of the Metropolitan Life Insurance Company in 1917. From left to right are Paul Lichti, J. C. Harmson, Floyd Kemp, Percy Rodgers, J. Terrell, G. Bohourron, Frank Rodgers, and Art Pabst. (Courtesy HSPV; donated by Harmson family.)

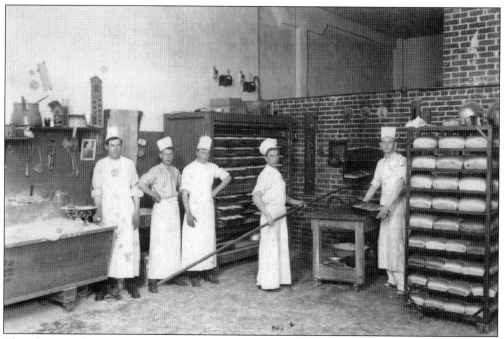

This photograph of the Pomona Bakery was taken in the early 1920s. The bakery was located in the 200 block of West Third Street until 2003, when it was closed and the building was remodeled for other use. (Courtesy HSPV.)

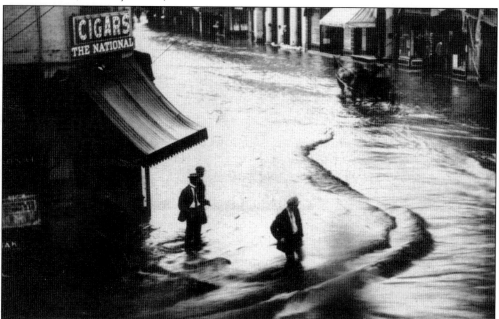

For many years, Second Street flooded each and every time there was a heavy rainfall because of the banks of the San Jose, Pedregoso, and other small creeks overflowing and returning to their natural path. Several river-rock channels were built as a part of the WPA projects in the 1930s, but the problem continued on into the 1940s and 1950s. In the 1950s, Pomona passed a bond and installed an extensive flood control system. (Courtesy HSPV.)

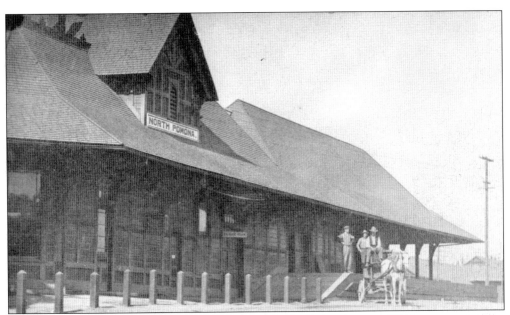

The Santa Fe Railroad station was located on North Garey Avenue. This area was not an incorporated part of Pomona and was called North Pomona. (Courtesy HSPV.)

Pomona was the first city in California to start a campaign for a new YMCA building after World War I. Construction began in 1920 on this beautiful mission-style, redbrick building designed by Robert Orr. The $300,000 cost of the building was more than twice the original estimate. The dedication ceremony was held in April 1922. Over 100 servicemen per day used the YMCA during World War II. (Courtesy Pomona Public Library.)

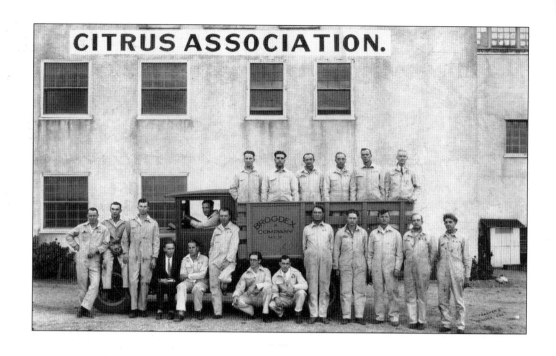

Brogdex, one of the early distributors of fruit in Pomona, still has an administrative office on Second Street in Pomona and is the largest distributor of fruit in the world. (Courtesy HSPV.)

This two-story craftsman home is located at 305 East Kingsley Avenue, formerly called Piedmont, in the Lincoln Park Historical District. It has clapboard siding and a cross-gabled roof with protruding brackets and exposed rafter tails. It was constructed in 1909 for William A. Kidd, who was employed as a shingler. It was the home of James H. and Ida Kelly Kidd in the 1920s. The house is still a beautiful home today. (Courtesy HSPV; donated by Geraldine Espiau.)

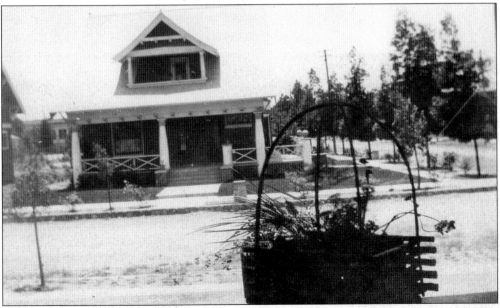

This house is located on the southwest corner of Gibbs Street and Kingsley Avenue at 310 East Kingsley. The home was constructed in 1909 for H. F. Norcross, who was employed as an orange grower. The interior, garage, and rear of the house were extensively restored several years ago by Joy and Ken Pifer. (Courtesy HSPV; donated by Geraldine Espiau.)

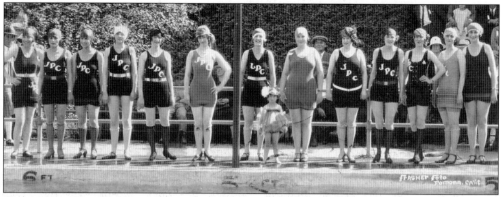

The first Miss Pomona contest was held in 1925 at the Ganesha Plunge in Ganesha Park. The eighth young woman from the left was crowned Miss Pomona. (Courtesy Pomona Library.)

The Women's Community Building is located on the southeast corner of Third Street and Garey Avenue. It measures 65 feet by 105 feet and is two-and-one-half stories tall. This photograph taken by Frasher was donated to the Historical Society of Pomona Valley many years ago by Pomona Realty Company. (Courtesy HSPV.)

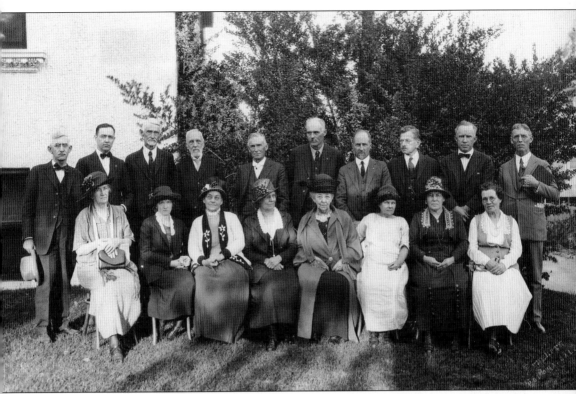

This photograph of the members of the Historical Society of Pomona Valley was taken on the lawn in front of the Pomona Library in the afternoon of May 14, 1924, following a meeting. The program was A. W. Burt speaking about the San Antonio Light and Power Company. Pictured are, from left to right, (first row) Kate Fleming, Mrs. J. C. Penley, Mrs. E. M. McComas, Mrs. A. W. Burt, Martha Bray, Mrs. J. E. Adamson, Mrs. W. S. True, and Mrs. E. S. Williams; (second row) W. A. Vandegrift, H. B. Westgate, P. S. Martin, J. A. Dole, A. W. Burt, E. S. Williams, J. E. Adamson, O. H. Duvall, D. E. Decker, and B. A. Rice. (Courtesy HSPV.)

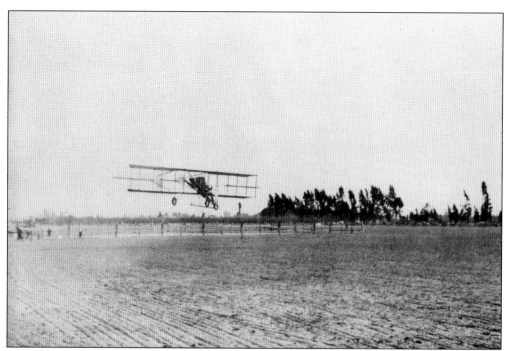

This photograph shows Cal Rogers landing in Pomona as a part of his transcontinental flight in 1911. Pomona was involved in the fast-growing field of aeronautics early on because of its facilities for landing and servicing airplanes. (Courtesy Pomona Public Library.)

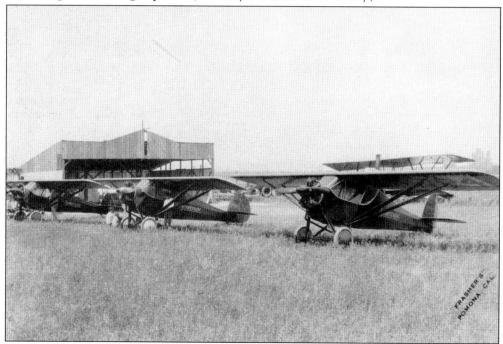

Burnley Airport opened in Pomona in 1928. It was located near what is today South Garey Avenue. In 1928, the largest privately owned airport in the United States was W. K. Kellogg field, also located in Pomona. (Courtesy Pomona Public Library.)

Four

THE GEMS OF POMONA

Ricardo Vejar and Ygnacio Palomares brought tutors from the San Gabriel Mission to educate their children. Later the sister of Palomares, Josefa Arenas, taught formal classes in the Casa Alvarado.

The San Jose School District was established in 1867 and later a building was constructed on the corner of Temple Avenue and Pomona Boulevard. In addition to Pomona and Spadra, the San Jose School District served Claremont, La Verne, San Dimas, and Walnut.

In 1870, the Palomares School District was formed with Cyrus Burdick, Juan Garcia, and Francisco Palomares as its first trustees, and a room was rented in the Tomas Palomares Adobe. In 1871, a rough building was constructed at Park Avenue and Gordon Street. Classes were taught in Spanish and English as more Anglo families moved into the area.

About 1876, the old Central School was built on Park and Holt Avenues. The three acres next to the school were cultivated with flowering shrubs and trees to provide shade and a welcoming environment for the students. In 1883, Central School principal F. E. Little dealt with discipline issues by publishing a report in the local newspaper on each student containing the student's attendance, deportment, and scholarship. Parents became very interested in their young students.

In 1888, when Pomona officially became a city, the Palomares School District became the Pomona City School District. The district had four buildings, accommodations for 450 pupils, and 9 teachers, although attendance was around 500 pupils.

On August 13, 1890, the 10th grade was added; on September 10, 1891, the 11th grade; on June 22, 1892, the 12th grade; and on July 15, 1893, kindergarten was added. In 1916, the junior college curriculum was added and was taught until 1946, when Mount San Antonio College was formed.

Today Pomona Unified School District serves 32,000 students in 43 schools consisting of 29 elementary, 6 middle, 4 comprehensive high schools, a high school of choice, alternative high schools, and adult and career education. Leading national colleges and universities recruit graduates from the Pomona schools. The school district is the largest employer in Pomona, with 3,000 employees.

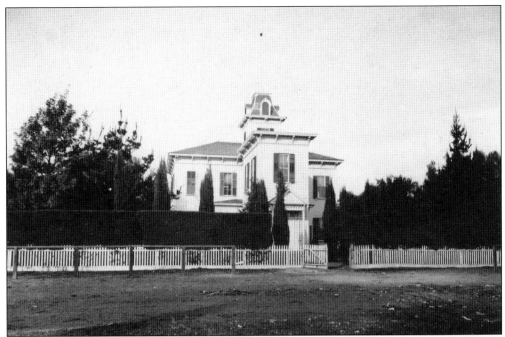

No photographs are available of the first school building, a small, roughly hewn, wooden building near present Park and Orange Grove Avenues called Central School. The new Central School in the photograph above was built about 1876 on three acres on Park and Holt Avenues. At first, it served students in grades first through eighth. The International Order of Odd Fellows contributed $1,000 toward the building with the condition they could use the second floor as a meeting room. (Courtesy Pomona Public Library.)

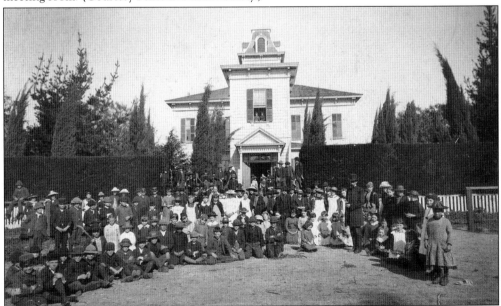

In 1884, Central School was enlarged to house a total of 400 students as the population grew with more students coming into the area. By 1888, the census for the number of residents between the ages of 5 and 17 years was almost 700 students. (Courtesy Pomona Public Library.)

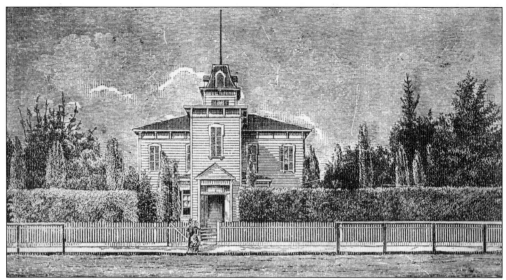

This drawing of Central School was done by J. A. Ludden Sr. and appeared on the pamphlet distributed by the Pomona Land and Water Company in 1888 in an effort to entice people to buy land and relocate to Pomona. Not only did Pomona offer rich, fertile soil—an urban paradise—but it also offered an excellent school for the children. (Courtesy Pomona Public Library.)

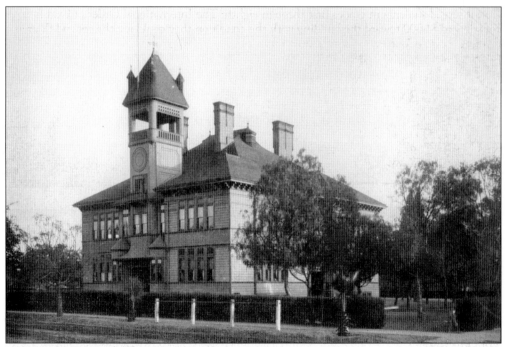

The new Central School and the Sixth Street School were counterparts of one another with the tower and the two round turrets in the front. Sixth Street School, shown above, was constructed shortly after the new Central School in 1892 and served students in what was then the more southern part of the city. (Courtesy Pomona Public Library.)

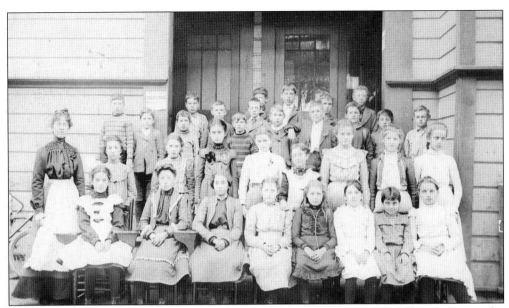

This photograph is of a fifth-grade class at Central School. The teacher is Lillian S. Scott, who later became the second wife of the widower Hugh Thatcher. Thatcher was a member of the Los Angeles County Board of Supervisors during 1930–1934 and was chairman of the County Flood Control Board. He was one of the organizers and the general manager for the Pomona Fruit Packing Company. (Courtesy Pomona Public Library.)

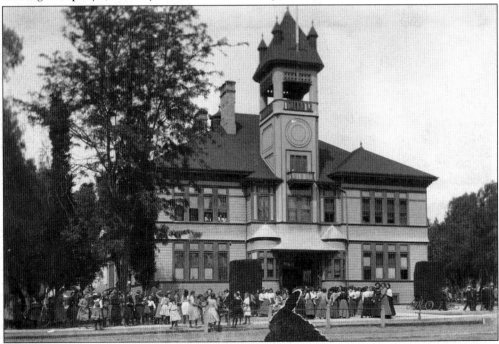

The building in the photograph above was built in front of the Old Central School and was known as the New Central School. Grades 9 through 12 were added to provide the full public-school experience. This photograph appears to be of high school and middle school students. This photograph is believed to have been taken in 1900. (Courtesy Pomona Public Library.)

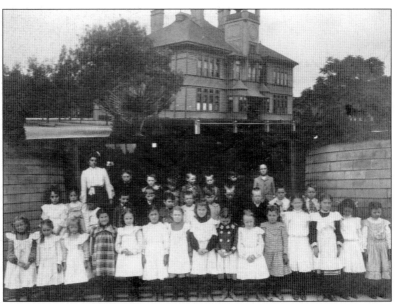

This photograph of the New Central School shows the elementary class of Nettie I. Fox in front of the school. This particular class is also integrated with both Spanish and Anglo children. (Courtesy Pomona Public Library; donated by Mrs. D. S. Fox.)

This photograph is of the 1894 grammar-school class. The names of the students are listed on the back of the photograph but some are very difficult to read. They appear to read Kirby Ruth, Dora Loney, Annar Mahler, Fred Allen, Alice McClintock, Kate Layne, Irving Harris, Eva Henderson, Allie Middaugh, Earl Wallace, Edith Mole, Will Burr, Mamie Dewey, Winnie Warren, Arthur Brady, Edith Soper, Ed Dreker, Ethie Thomas, Gertie Skinney, Gus Caldwell, Mamie Craig, Ralph Myers, Mabel Mosher, Mabel Bennett, Paul Uesher, Amelia Laughrey, Archie Scott, Mary Parker, Cornelia Bowen, H. C. F., M. A. R., F. A. M., K. A. F., A. D. H., Dora Mosher, Bert Clogston, Lillie Ostrem, Will Craig, Ida Lehman, Eddie Mathes, Lizzie Eells, Fred Dreker, Gracie White, and Will Kessler. (Courtesy Pomona Public Library.)

This photograph of Pomona High students was taken around 1906. Guenevere Metkiss was the teacher, and Paul Kaufman was the principal. (Courtesy Pomona Public Library.)

This photograph of the high school at Central was taken about 1894. The photograph was donated to the Historical Society of Pomona Valley by Mrs. Hugh Thatcher in March 1938. (Courtesy Pomona Public Library.)

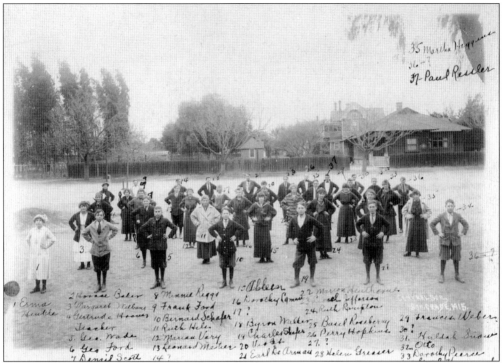

This 1915 photograph of a class of students at the Central School site shows, from left to right, Old Central School, New Central School, and the kindergarten building in the background. The only building that survives today is the kindergarten, known as the Barbara Greenwood Kindergarten, which was moved to McKinley Avenue and Hacienda Place and is completely restored. The kindergarten is a local, state, and national historical landmark. (Courtesy Pomona Public Library.)

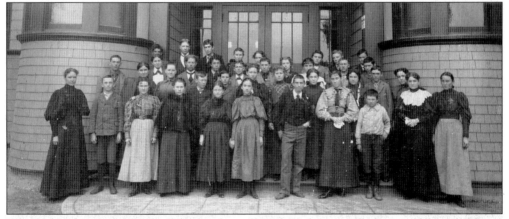

The students at Central School in the class of 1894 are shown with their teacher, Ada Miner. Only a partial list of the students is available today and includes Frank Seaver, Lizzie Riley, George Jess, Ambrose Bresnahan, Albert Bresnaham, Bertha Pratton, Lena Goodwin, Carl Lorbeer, Dick Rose, Maude McComas, Myrtle Deck, Bertha James, Phillip Weber, Nora Perrin, Mabel St. John, Thos Crawford, Martine Huddleston, and Fannie Hinman. (Courtesy Pomona Public Library.)

This photograph shows the graduating class of Pomona High, which was the New Central School. The class graduated on May 8, 1985. Their class colors were crimson and yellow, and their flower was the rose. The teacher was Katharine Augusta Fall, and graduates were Arthur Mac Donald Ellis, Mary Grace Carpenter, Florence Beatrice Flood, Lillie Belle Scott, Evalyn Austin Layne, Edward Lee Payne, Sadie Lewis, and Nellie Mae Bennett. (Courtesy Pomona Public Library.)

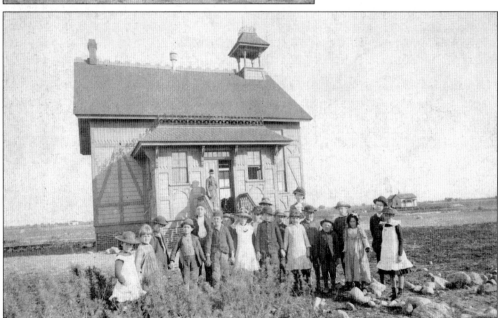

This photograph shows the Kingsley Tract School, consisting of one room, which opened in 1884–1885. The building was located on what is now San Bernardino Road and Washington Avenue. Myrtle Deck, later Robinson, is shown in the photograph. (Courtesy HSPV.)

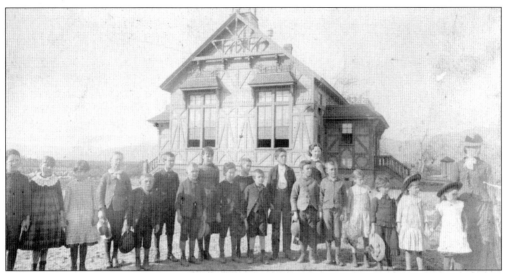

This photograph was taken about 1887 and shows a side view of Kingsley District School. Ada Miner, who later taught at Central, was the teacher. The students from left to right are Tom Doyle, Lilly Kiler, Alice Doyle, Diamond Le Clair, Charles Cathcart, Alva Lawrence, Bob Cathcart, Winnie Warren, Dick Rogers, Charles Peck, Roy Kiler, Orren Camp, Minnie Rogers, Clint Hibbard, Ed Peck, Nellie Lawrence, Gertrude Hibbard, Anna Doyle, and Blanche Rogers. Kingsley was an elementary school from the 1884–1885 school year until it ceased operations in 1916. The building was remodeled in the 1920s and used as a residence with an address of 975 San Bernardino Road. (Courtesy Pomona Public Library.)

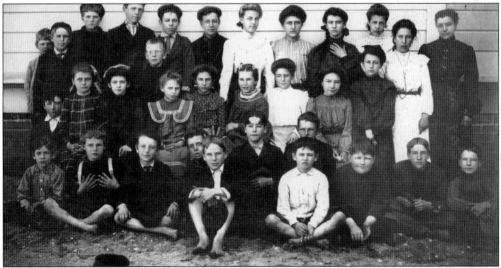

This 1904 photograph shows some of the students at Kingsley School on San Bernardino Avenue, just east of San Antonio. The names of the students in the photograph who are known are, from left to right, (first row) two unidentified, Roy MacIntyre, five unidentified, Harcourt Blades, John Adams, and Julius Becker; (second row) unidentified, John Hendricks, two unidentified, Elmer Becker, two unidentifed, Kathrine Scott, Winifred Schaffer, and Nellie Ulery; (third row) two unidentified, Ike Moncreif, Elmer Klase, Earl Gillen, Horace Ulery, Nellie Himrod, ? Wolch, Eva West, Minnie Himrod, ? Straley, unidentified, and Eddie Himrod. (Courtesy Pomona Public Library.)

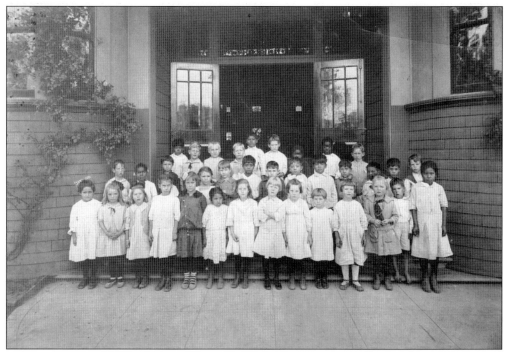

This photograph of the primary grades in front of Central School was taken in the early 1920s and shows the diversity of the student population of Pomona. Even today the diverse population of Pomona is its greatest strength. (Courtesy Pomona Public Library.)

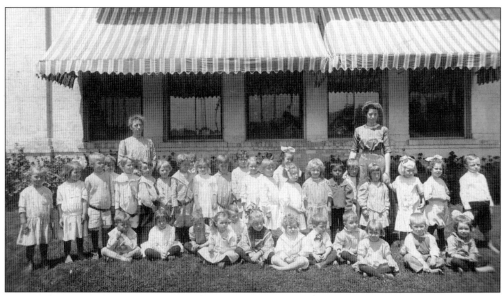

This photograph of the Garey Kindergarten was taken in the 1920s. Miss Eells was the teacher, and Vyenne Fpuder was the assistant principal. (Courtesy Pomona Public Library.)

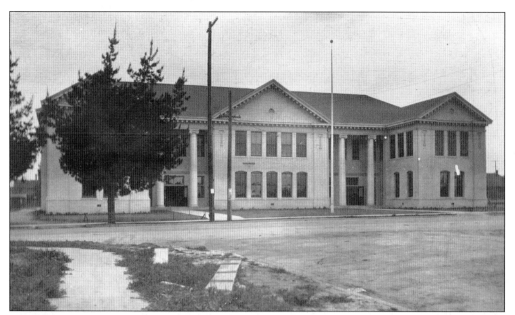

This 1910 photograph shows the Garey Elementary School, which was built in 1909 and was located at 1200 North Garey Avenue. (Courtesy Pomona Public Library.)

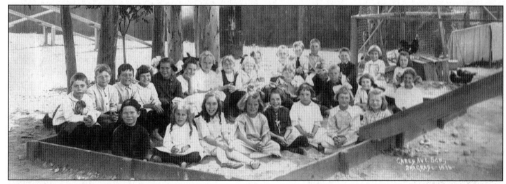

This photograph shows the second grade at Garey Avenue Elementary School in 1916. Garey Avenue School was located on the site where Lincoln Elementary is today. However, Garey Elementary faced Garey Avenue, whereas Lincoln faces Gordon Street. Garey School was made of redbrick, which was reused for the fence around the Lincoln playground. The children are playing in a homemade sand box with chickens in the background. (Courtesy HSPV.)

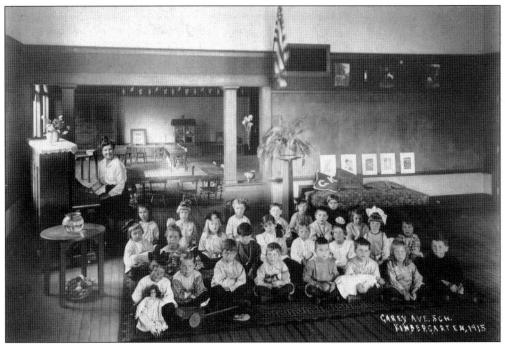

Elizabeth Zilles was a member of this 1917 third-grade class at Garey Elementary. The teacher was Miss Blackmore. Elizabeth grew up in Pomona, and her father had a jewelry store on Second Street. Elizabeth became a professor at Scripps College in Claremont. She served as president of the board of directors for the Historical Society of Pomona Valley and was very involved in civic affairs in the city. (Courtesy HSPV; donated by Dawn Van Allen.)

The Sixth Street School, built in 1892, was located between Sixth and Seventh Streets and Gordon Street and South Park Avenue and originally served students in the first through the eighth grades. Kindergarten was added the following year. Pomona was very proud of the fact that it provided kindergarten space to every tot in the city. One of the people shown in this 1906 photograph of the kindergarten is Elizabeth Eells. (Courtesy HSPV; donated by Mrs. Eells.)

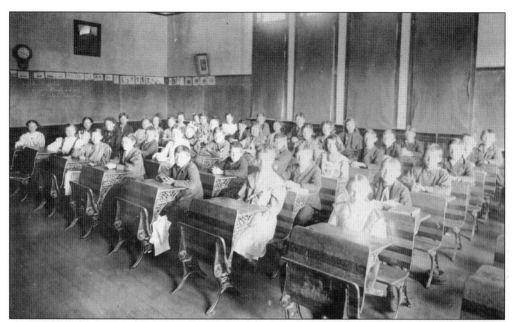

This photograph is of a class at the Sixth Street School about 1907. For a very few years in the 1930s, the school was known as Lincoln Elementary prior to the new Abraham Lincoln Elementary being built on Gordon Street. Once the new Lincoln Elementary was built, the name of this school returned to Sixth Street School. (Courtesy Pomona Public Library.)

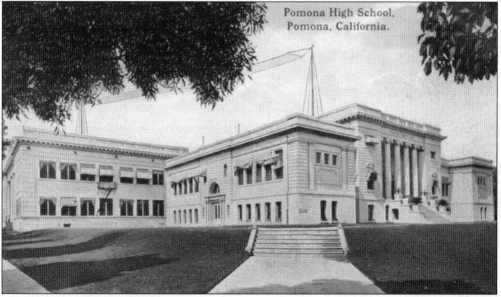

In 1903, Pomona High School students moved from the Central School site to this new building on the corner of Gibbs and Pearl Streets, giving high school students their own building for the first time. The Pomona High School building was erected at a cost of $55,000. In 1916, the junior college curriculum was added. In 1924, when the new Pomona High was built, it became the first Emerson Middle School and was used for a middle school until the new Emerson Middle School was built. Today senior-citizen apartments are located of the site and are named Emerson Village in honor of the school. (Courtesy Gallivan family.)

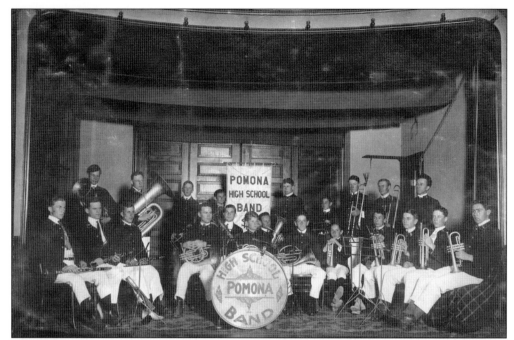

In this photograph of the 1915 Pomona High School Band, the only known names of the players are Norman McLeod (French horn player to left of the drum), Edgar Adamson (third clarinet), Water Hile (tuba), Harry Hile (far right trumpet), and Jean Kinney (euphonium to the right side of the banner). (Courtesy HSPV.)

Hamilton Grade School opened in 1910. This photograph of the Hamilton sixth-grade class was taken in the 1940s. (Courtesy Pomona Public Library.)

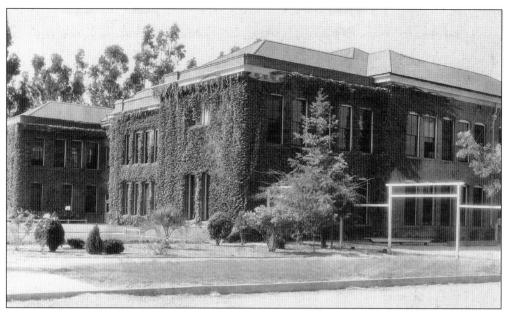

Originally opened in 1910, this photograph shows the old Hamilton School in the 1920s. The walls are covered with ivy. The new Hamilton School to replace it was built in 1946. (Courtesy Pomona Public Library.)

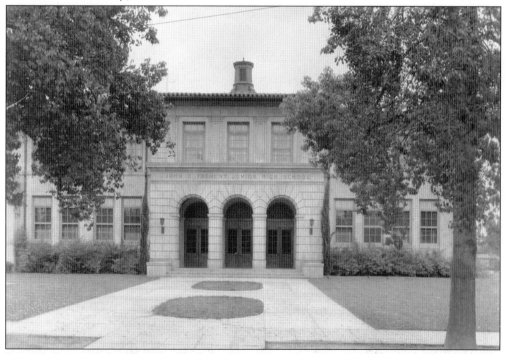

Fremont Junior High School was built in 1928 and was located on South Garey Avenue. After earthquake standards were enacted, the building could no longer be used to house students and was converted to the administrative offices. Although the building has since been retrofitted, it still serves as the primary administration building for the Pomona Unified School District. (Courtesy Pomona Public Library.)

This photograph of Fremont Junior High School was taken in 1932, when the building was still used as a junior high. The wing on the right side houses the beautiful auditorium with a large stage. Although the seating capacity of the auditorium is limited, the entire district uses the auditorium for events. (Courtesy Pomona Public Library.)

Alcott Elementary School, located on South Towne Avenue, was built in 1927. (Courtesy Pomona Public Library.)

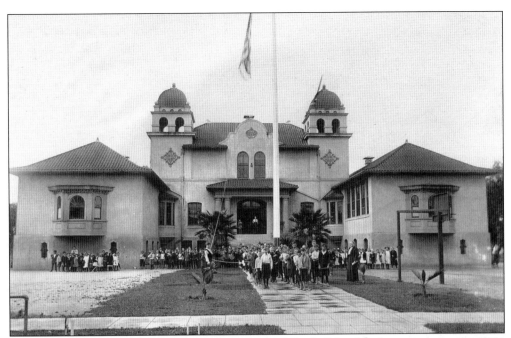

This mission-style building was called the Fourth Ward Grade School and was constructed in 1904 at a cost of $30,000. It was located between Sixth and Seventh Streets and Palomares Avenue and Elmira, now Elm Street. The school taught students from the first through the seventh grade. In 1917, it was converted to a junior high school, now called a middle school. (Courtesy Gallivan family.)

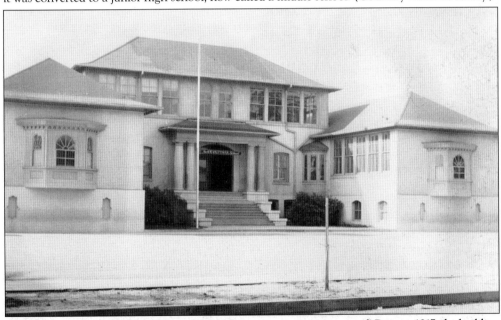

This photograph is of Kauffman School after the two towers were removed. Prior to 1917, the building was renamed Kauffman School in honor of Paul W. Kauffman, who served as superintendent of Pomona City Schools for several years. Kauffman School was used as a middle school for several years and then as a grade school until it was determined no longer suitable for a school building. (Courtesy Pomona Public Library.)

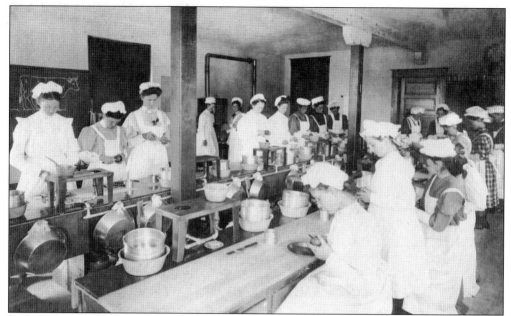

This photograph shows a cooking class at Fourth Ward School in March 1909. The basement of the building was used for manual training and the domestic sciences department. All seventh-grade girls were instructed in the domestic sciences and all boys in woodworking. Boys could also take woodworking in the summer at this facility, and approximately 160 boys participated the first summer it was offered. Mildred Alderman was the teacher for this class. (Courtesy Pomona Public Library.)

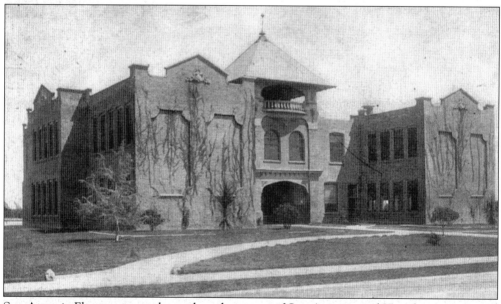

San Antonio Elementary was located on the corner of San Antonio and Kingsley Avenues and was constructed at a cost of $30,000 in 1903. It consisted of 10 large classrooms, library, office, lunchroom, restrooms, and cloak and bicycle rooms. It was considered to be the best-lighted school building in Southern California, as the architect designed it so that all windows had a northern exposure. (Courtesy HSPV.)

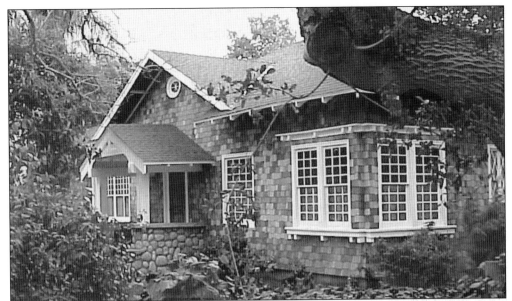

The Barbara Greenwood Kindergarten bungalow opened for classes at 605 North Park Avenue in 1908. In 1929, it was moved to the old San Antonio School site, and in 1951, it was again moved to Arroyo School. In 1974, the building was deeded to the Historical Society of Pomona Valley, and the building was moved to the Historical Society of Pomona Valley's site on the corner of Park and McKinley, where it stands fully restored today. (Courtesy Pomona Public Library.)

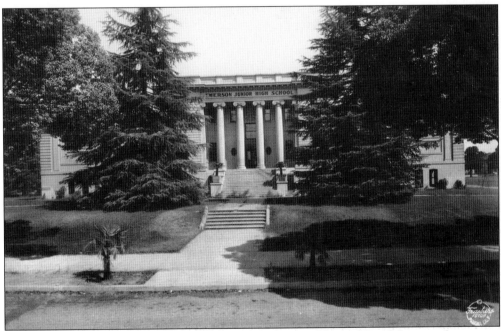

This photograph is of the old Emerson Junior High on Gibbs and Pearl Streets when it was being used as a junior high school. This building was the first Pomona High School but was converted to a junior high after the new Pomona High opened on Holt Avenue. (Courtesy Pomona Public Library.)

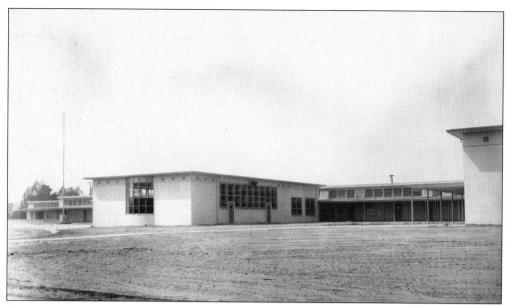

This photograph is of the newly constructed Ralph Waldo Emerson Junior High as viewed from the southeast in September 1949. Emerson is located on the corner of Lincoln and Towne Avenues. (Courtesy Pomona Public Library.)

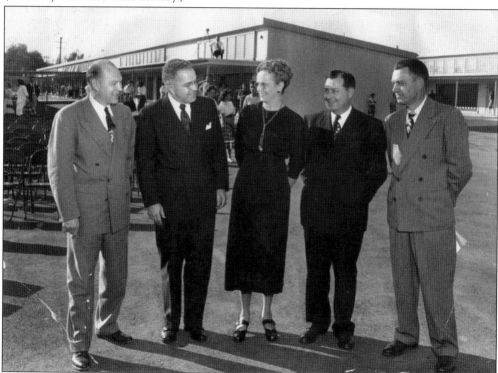

This photograph shows, from left to right, Burton Botek, county superintendent of schools; Leroy Allison, Pomona city superintendent of schools; Ruth Tangeman, vice principal; Aubry Hays Simons, principal; and Mr. Simpson, state superintendent of education, at the dedication of the new Emerson Junior High School, now Emerson Middle School. (Courtesy Pomona Public Library.)

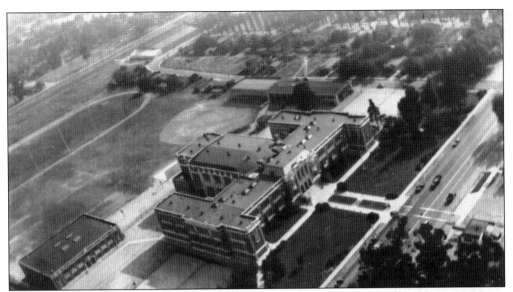

The aerial view of the new Pomona High School on East Holt Avenue and San Antonio shows the entire campus. Only the main building was damaged by the fire on May 14, 1956, that was deliberately set by a disgruntled faculty member. The decision to tear down the remains of the school and to build Ganesha High and the new Pomona High is considered today to be one of the worst decisions ever made by the Pomona School Board. (Courtesy Pomona Public Library.)

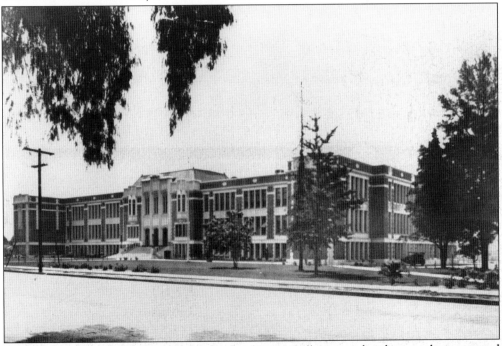

On September 22, 1924, Pomona High School and Junior College moved to these newly constructed buildings on East Holt Avenue and San Antonio. The buildings cost $500,000 and contained the largest auditorium in the city with a seating capacity of over 2,000 and the largest stage in Southern California and perhaps the best equipped on the Pacific Coast. (Courtesy Pomona Public Library.)

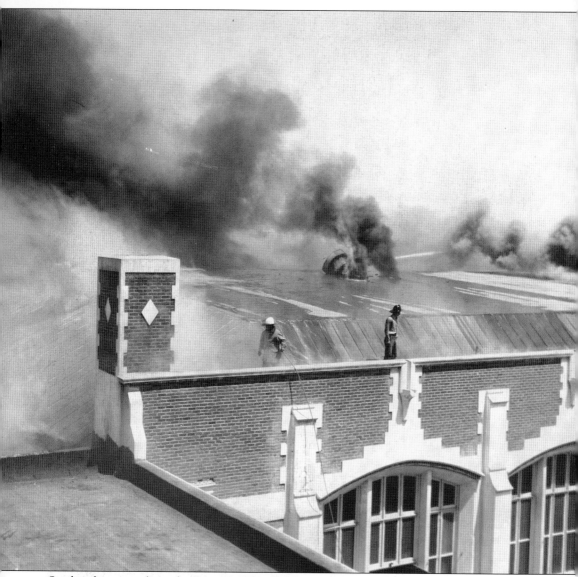
On the afternoon of Monday, May 14, 1956, students at Pomona High were called out of fifth period by the fire alarm. It was one of the most spectacular fires in Pomona's history, totally destroying the auditorium and severely damaging the rest of the building. (Courtesy HSPV.)

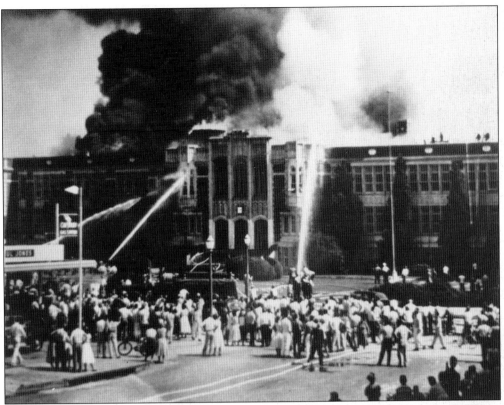

The full force of 68 firemen, assisted by fire units from Chino, Los Angeles County, La Verne, Claremont, and Ontario, battled the blaze for four hours. (Courtesy Pomona Public Library.)

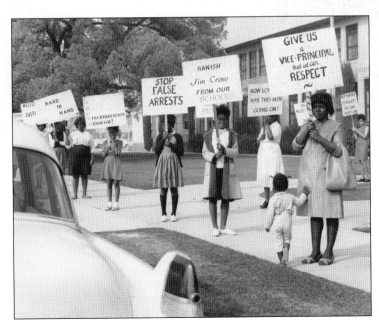

This 1963 photograph shows parents picketing in front of the Pomona Unified School District administrative office. Parents were very upset about the actions of one of the principals and were demanding he be replaced, as they felt he was not sensitive to the black student population. (Courtesy HSPV.)

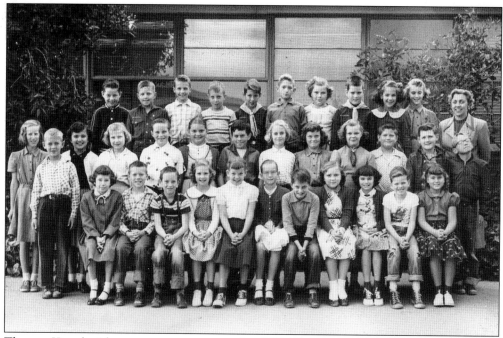

The new Kingsley Elementary was constructed in 1953. This photograph shows the fourth-grade class at Kingsley in 1955. The teacher was Miss Moline. One of the students was Robert Coons. (Courtesy Constina Keith.)

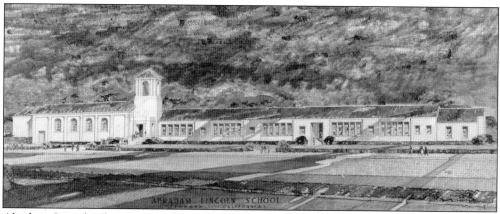

Abraham Lincoln Elementary was the first earthquake-resistant building constructed in Pomona and the first such school in California. Designed by Pasadena architects Marston and Maybury, contractor O. H. Hauser completed the school in 1936 at a cost of $118,000. The structure features a tile roof and a bell tower, all-maple flooring, 10 classrooms, cafeteria, kitchen, offices, and storerooms. The auditorium is built of reinforced concrete. Bricks from the old Garey Avenue School were reused to build the wall surrounding the perimeter and playground. It was famous for being the last word in construction and is the oldest school in the district still used for classrooms. It is listed on the National Registry of Historical Places. (Courtesy HSPV.)

Five

GARDEN SPOTS OF THE VALLEY

In 1888, Patrick C. Tonner purchased the land that was to become the first park in Pomona, present-day Ganesha Park. He planted eucalyptus trees, introduced an ostrich farm, and made various other improvements. In 1890, the city purchased nine acres, and that same year, Tonner donated another three adjoining acres. From 1890 to 1914, additional acreage was added to the park until the park grew to more than 60 acres. Tonner named the park after the Hindu god Ganesh, the god of good things and water.

The lush site, which had once served as campsites for Native Americans, is designated as a burial site, with the burials documented through pottery fragments and burial positions to have taken place about 1860. (According to the Archaeological Site Survey Record of the University of California, the site is CA-LAN-208, dated August 29, 1968. The Native American Heritage Commission also recorded the archaeological site.) The cause of deaths is linked to the smallpox epidemic of that time period.

The river-rock stairs and paths that meander through the hills of the park were built prior to 1907 and have endured throughout time. They lead up the steep hill to the lookout point overlooking the Pomona Valley. The park has been said to have the most beautiful view of any place in the world. On top of the hill is a lovely tree with above-ground roots that encircle the hill to form a natural boundary. The circular reflection pool on top of the hill has now been filled with soil and plants.

Soon after Ganesha Park was founded, Central and Lincoln Parks were developed. Over the years, the City of Pomona has continued to add more parks to meet the increasing and divergent needs of the community. The parks have changed from beautiful garden settings for leisurely walking to areas for family cookouts, children's playgrounds, and sports fields. Today there are 26 parks, including Veteran's Park currently in development, and a staff of approximately 120 employees to meet the recreational needs and to provide the care needed for the beautification and safety of the parks.

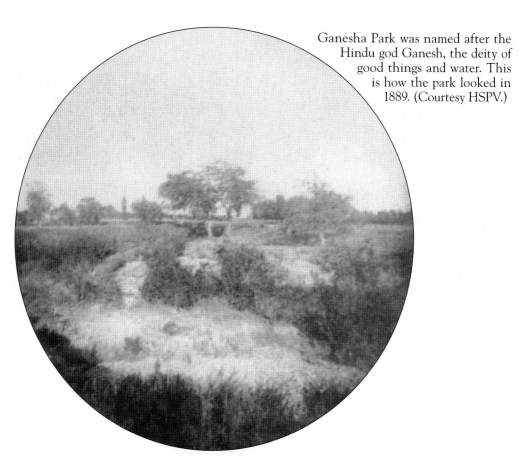

Ganesha Park was named after the Hindu god Ganesh, the deity of good things and water. This is how the park looked in 1889. (Courtesy HSPV.)

The San Jose Creek ran freely through Ganesha Park until the 1930s, when the river-rock channel was constructed as a part of the WPA. The Newman Post Card Company published this image of the creek with the bridge across it around 1908. (Courtesy HSPV.)

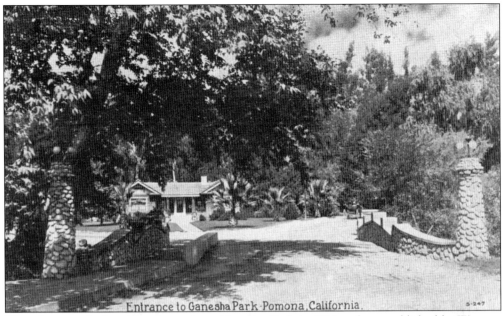

This photograph shows the entrance to Ganesha Park in 1914 and was published by Western Publishing and Novelty Company. (Courtesy Gallivan family.)

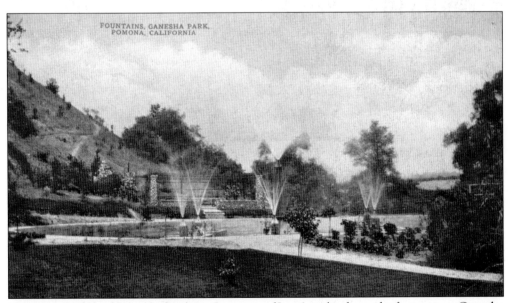

This photograph published by Benham Company of Los Angeles shows the fountains at Ganesha Park. (Courtesy Gallivan family.)

The San Jose Creek ran freely through Ganesha Park until the channel was built to prevent flooding as a part of the Work Project Act. (Courtesy Pomona Public Library.)

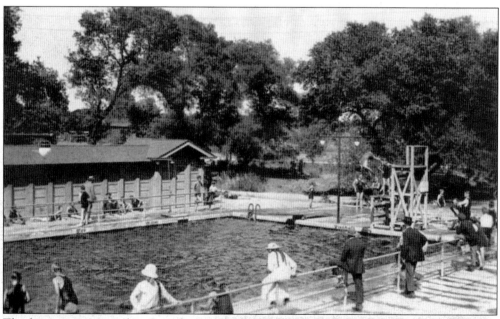

The first swimming pool in Ganesha Park, named the Ganesha Plunge, was built in 1915 when Pomona had a population of 12,000. It immediately proved to be very successful among the residents, and its popularity has never waned. The pool was renovated in 1957, when the population had grown to 51,348. A blot on the community associated with the Plunge is that its use by minorities was restricted to only one day per week, and that was the day before the pool was drained each week. (Courtesy Pomona Public Library.)

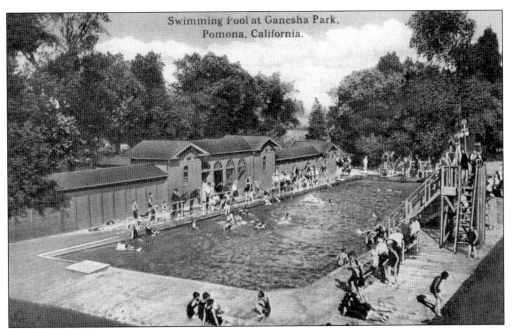

The original plunge was last used in the summer of 1984, at which time the population of Pomona had grown to 106,345. The pool was determined to be unstable because of severe undermining. The city demolished the pool and started fresh by building a new pool on the same site in 1988. (Courtesy Pomona Public Library.)

George W. Burton, traveler and scholar, writes in 1909 in the *Pomona Daily Review*: "I stood upon the topmost point in Ganesha Park and looked over the valley. . . . There is not in all the vast stretch of the world . . . a spot to be compared with the valley around Pomona, as viewed from the top of the City's new park." (Courtesy HSPV.)

These steps leading up Ganesha Hills to Inspiration Point were constructed prior to 1909 and are still relatively in tact. They are made with a river-rock base and poured concrete. Many of the finials have been damaged. (Courtesy HSPV.)

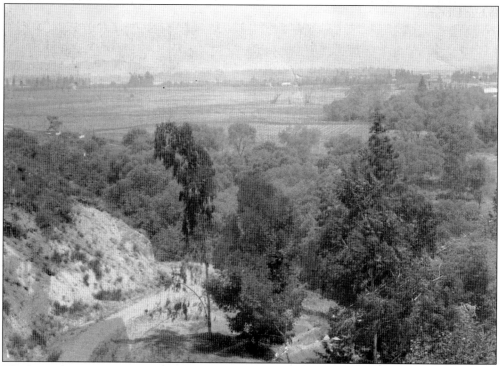

The beautiful trees and greenery add to the beauty of the view of the Pomona Valley as viewed from the Ganesha Hills. (Courtesy HSPV.)

Although much larger, the Ganesha Park pavilions today resemble this grandstand of the early 1920s in terms of the use of the river rock and the shape of the grandstand. The city has made a concentrated effort to continue to use the river rock in the park. (Courtesy Pomona Public Library.)

May Day was observed in Ganesha Park on May 1 in the early 1920s with a maypole and all of the little girls and boys dressed in white. (Courtesy Pomona Public Library.)

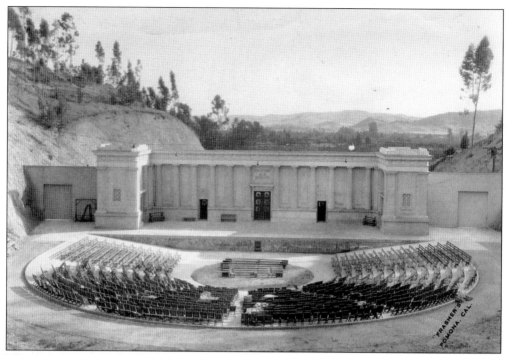

The very elegant Greek Theatre was constructed in 1916 by William J. Wilton Company. Many outdoor pageants and musical concerts were performed on the stage. Graduation ceremonies for the class of 1956 were held in the early evening in the theater. It is reported that the theater was not usable because of the noise after the construction of the San Bernardino Freeway and was eventually demolished. (Courtesy Pomona Public Library.)

The Greek Theatre is seen through the trees above the theater. (Courtesy Pomona Public Library.)

The road went through the San Jose Hills on the way to Anaheim. Today the San Jose Hills are known as Ganesha Hills, but the breathtaking view has not changed. (Courtesy Pomona Public Library.)

At the top of the Ganesha Hills, near Inspiration Point, is a very large flowering tree. Many of the roots of the tree grow above ground and almost form a fence around the top of the hill. The tree is associated with the Goddess Pomona and formed a central part of the play entitled *The Myth of Pomona*. (Courtesy Gallivan family.)

The very tall rocket slide on the playground in Ganesha was every child's favorite. It was made of metal and had steep stairs winding around the slide. On the top was a small platform where children could wait their turn to go down the slide. The metal became worn and sharp in places. As the slide did not meet current standards for playground equipment, the city first put a barricade around it and finally removed it in 2006. (Courtesy Gallivan family.)

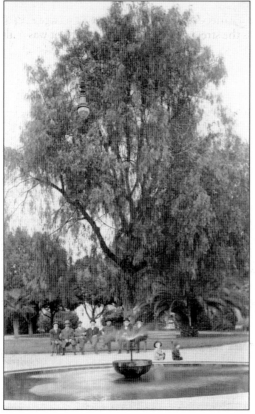

Central Park began as a block of eight separate parcels purchased by the city from 1887 through 1904 for a total of $9,501. The park construction was completed in 1904. (Courtesy Pomona Public Library.)

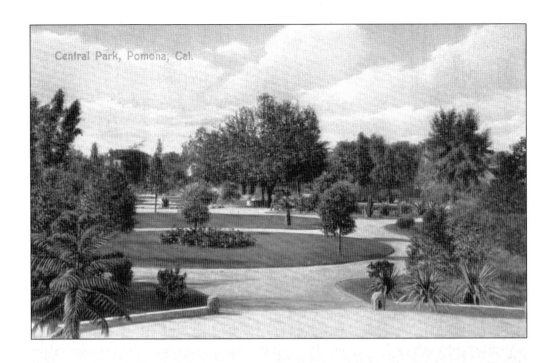

Originally Central Park was constructed to have a variety of landscapes, including a large area of desert plants. When the Armory was built across the street, the Armory's second floor was built to hold band concerts that could be enjoyed by those in the park. (Courtesy Gallivan family.)

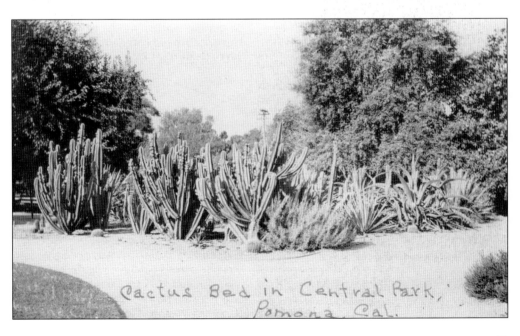

The Spanish War veterans' monument was placed in the park on a two-ton boulder found in the Ganesha Hills and transported by work camp members to the site. The monument consists of a piece of metal actually recovered from the remains of the battleship U.S.S. *Maine* and a small bronze marker with the date of the construction of May 23, 1923. The dedication was held in June of that same year. (Courtesy Pomona Public Library.)

This photograph shows the park as it looked in 1956. A small historical building served as Pomona's first community center. The park has been renamed Memorial Park and has a large oblique memorial listing the names of the young men and women who lost their lives in the service of our country. (Courtesy HSPV.)

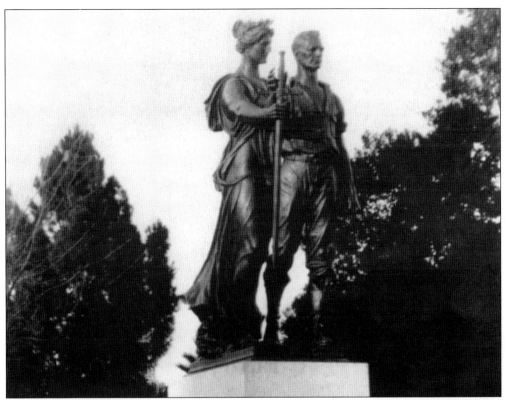

This beautiful bronze statue of the goddess Pomona by renowned sculptor Bert Johnson was unveiled in Garfield Park on Armistice Day, November 11, 1923. Garfield Park is located on East Holt Avenue and also has a plaque commemorating the planting of a tree from the Battle of Gettysburg. The tree has long since been removed. (Courtesy HSPV.)

This photograph shows Lincoln Park, located on Palomares Street between Lincoln and Jefferson Avenues. Although the park has changed considerably over the years, the circular park is the center of the Lincoln Park Historical District, the first and largest locally designated historic district in Pomona. Consisting of over 800 homes, the district is on the National Registry of Historical Places. (Courtesy HSPV.)

City crews are seen spraying the trees at Lincoln Park. The park has undergone few changes since this photograph was taken in the mid-1950s. (Courtesy HSPV.)

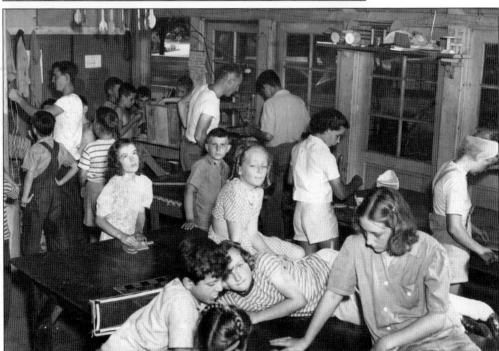

For several decades, Glenn Dee Dellenbach, a science and math teacher at Emerson Junior High School and a Boy Scoutmaster, singularly ran a summer recreation program at Ganesha Park. In the summer of 1946, the children were learning how to build wood and metal objects in a park building called "Mr. Dee's Shack." The building was an old greenhouse filled with metal and woodworking tools that Dellenbach had assembled from donors. (Courtesy HSPV; donated by Winter Dellenbach.)

Dellenbach also took the children on daily nature hikes, where they learned about the insects, birds, and other animals as well as the trees and plants in Ganesha Park. They completed a variety of nature projects. Both boys and girls attended the program. (Courtesy HSPV; donated by Winter Dellenbach.)

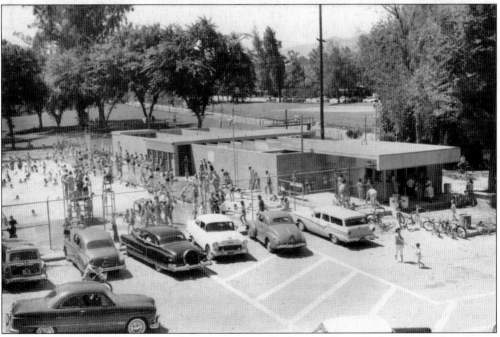

The second public swimming pool in Pomona was built in 1957 at Washington Park to better serve the residents of the southern part of the city. This photograph shows the opening day at the Washington Plunge. (Courtesy Pomona Public Library.)

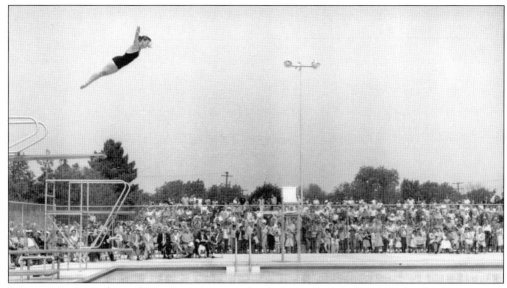

Guests were treated to a diving exposition at the dedication of the Washington Park Plunge on opening day in 1957. Here Olympic champion Paula Jean Myers is caught on camera performing one of her gold medal–winning dives. (Courtesy Pomona Public Library.)

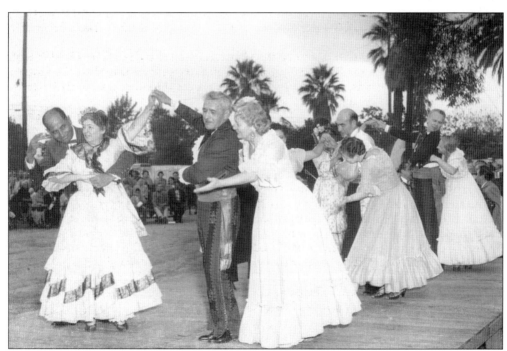

Traditional Mexican dances are performed at the dedication of Palomares Park in 1957. The park is located at 499 East Arrow Highway next to the Adobe de Palomares. (Courtesy Pomona Public Library.)

Six

THE CITY OF CHURCHES

Rev. Richard Fryer organized the first church in the valley in Spadra, Spadra Baptist Church, in 1870. It had 12 members and met in the Spadra School. The members moved to Pomona on October 3, 1883, and held services in a home until the First Baptist Church could be completed on the corner of Park Avenue and Fourth Street. There were 48 members.

The first religious sermon was preached by a Methodist minister in 1876 in the Southern Pacific Railway Station. The following year, the Methodists erected the first church building at Third and Gordon Streets.

The Reverend C. B. Summer organized the Congregational church on May 26, 1887, with 36 members. They met in the Pomona Opera House until the new church, where the Progress Bulletin building now stands, was built. Reverend Summer resigned to devote all of his time to developing Pomona College and was replaced by Dr. Frary.

The Church of the Brethren began on March 17, 1907, in a one-room building with old kitchen chairs for seating. In 1908, the church was electrified. In 1910, a new auditorium was built, and in 1925, the building was again enlarged. In December 1936, a fire severely damaged the building, and the congregation met at the YMCA until the church building at Fifth and Thomas Streets was purchased. After World War II, a 9-acre site was purchased on West Orange Grove Avenue and a new building constructed. The new building was first occupied on February 2, 1949.

The architecture changed through the years, from front entrances with steeples to corner entrances with large belfries. Later the Spanish influence was strong in the buildings, as was the California ranch type. As Pomona grew into a substantial city, more of the Gothic modified and English Gothic forms were seen. In the 1960s, educational buildings and gymnasiums were added to serve the youth. Although the styles of the churches have changed throughout its history, one of the mottoes for the City of Pomona has been "The City of Churches." Pomona has traditionally had more churches per capita than any other city in the United States. Today almost every block in Pomona has a church or some form of religious organization.

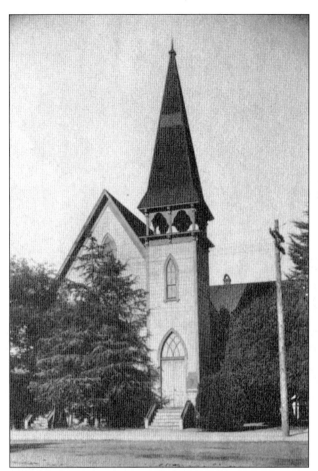

In 1887, the First Presbyterian Church of Pomona was located on the corner of Third Street and Garey Avenue. (Courtesy HSPV.)

On May 10, 1908, the dedication services for the First Presbyterian Church were held with 1,500 in attendance, although the church had only 440 members. The dedication of the Educational Building was held on September 28, 1930. The sanctuary was totally destroyed by a fire resulting from an electrical short in 1985 after serving the congregation for over 100 years. The Education Building was saved when a breeze from the southwest came up and stopped the fire. (Courtesy HSPV.)

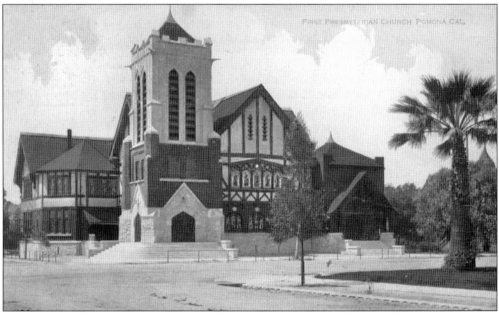

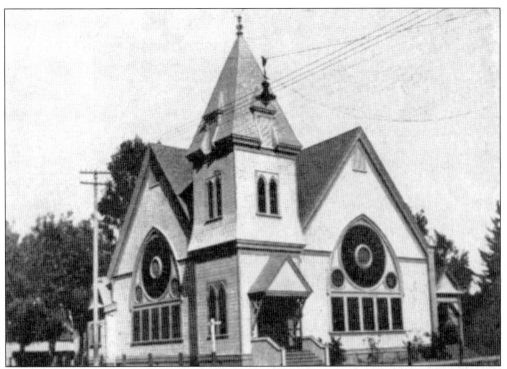

The First Christian Church of Pomona was organized on November 16, 1883, with 17 members. They first met in the justice of the peace's office until the congregation erected this building on Gordon and Center Streets in 1892. (Courtesy HSPV.)

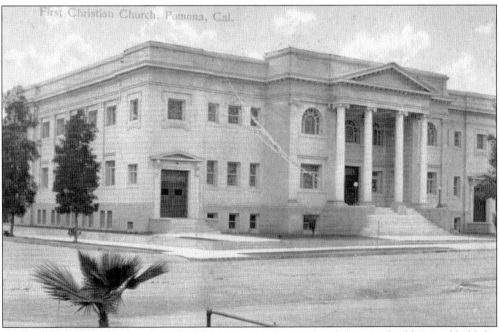

In June 1910, the First Christian Church congregation completed this new building and held the dedication. (Courtesy Gallivan family.)

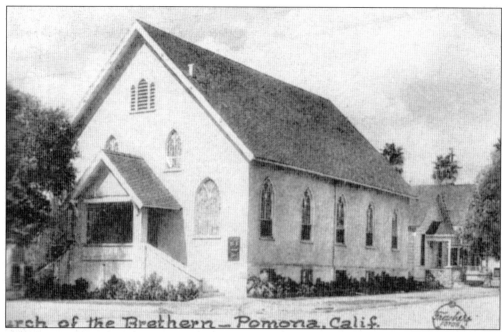

Church of the Brethren began in this one-room building with a platform and a speaker's stand at one end and old kitchen chairs for seating. It was located on the corner of Gibbs Street and Monterrey Avenue and cost $1,500. This photograph was taken in 1907. (Courtesy HSPV.)

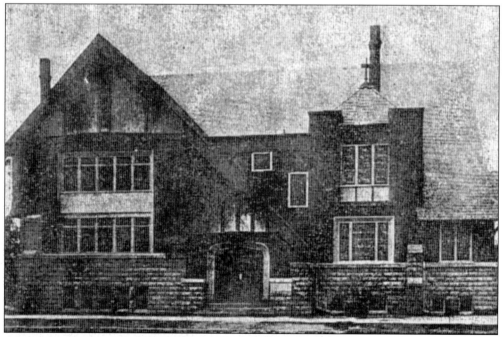

After a fire destroyed the first building, which had been enlarged several times, the Brethren purchased the Calvary Baptist building at Fifth and Thomas Streets. The building is shown in 1937. (Courtesy HSPV.)

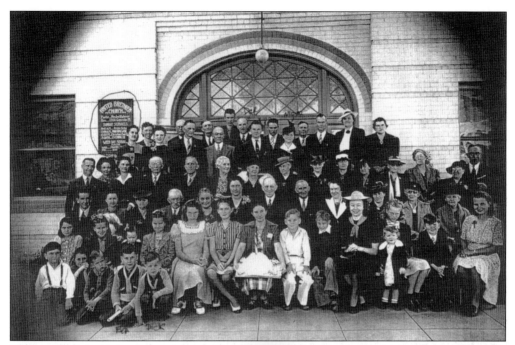

The congregation is gathered in front of the Church of the Brethren in the 1950s. (Courtesy HSPV.)

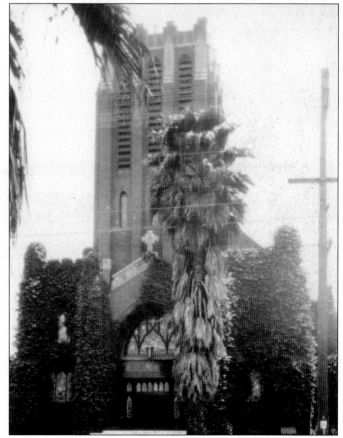

Construction for the Pilgrim Congregational Church, located at 600 North Garey Avenue, began in 1911 and was completed in May 1912. The architects for the beautiful, redbrick, Gothic Revival–style work of art were Robert Orr and Ferdinand Davis. The masonry work was done by I. N. Sanborn, and the stained glass-windows were made by J. R. Rudy. (Courtesy Pomona Public Library.)

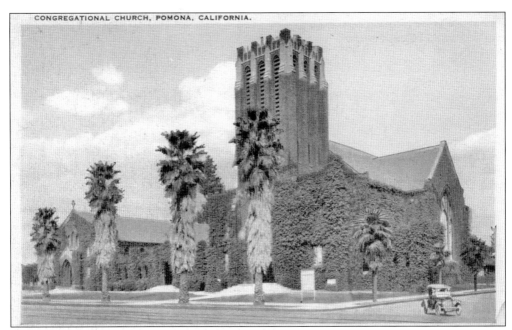

A fire badly damaged Pilgrim Congregational Church in 1925 requiring much restoration, at which time the memorial chimes were added. In 1954, the tower was rebuilt. An additional chapel was added to the building in 1962. (Courtesy Pomona Public Library.)

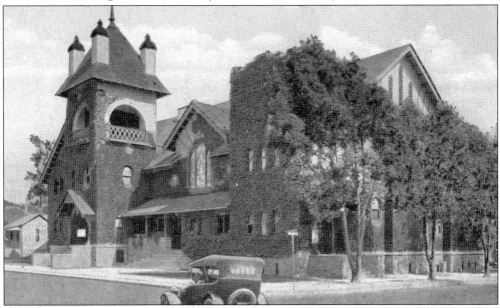

In 1908, Trinity United Methodist Church was built at Pearl and Gibbs Streets to serve the members of the congregation living on the north side of Holt Avenue. The Gothic Revival–style educational building, designed by Los Angeles architects Reginald F. Inwood and C. F. Schilling, was added in 1932. In 1953, architect B. H. Anderson designed the new sanctuary to be compatible in style with the older education building. The sanctuary is of the 16th-century English Tudor–Gothic style. It was built by Robert R. Jones of Los Angeles, with the Judson Company designing the stained-glass windows. (Courtesy HSPV.)

This Victorian masterpiece combining shingle style and Queen Anne architecture was originally built as a Methodist church. The current building was the second church on this site and was built at a cost of $2,250. It was dedicated in September 1883. Although it had a seating capacity of 300, by 1888, a larger church was needed. The 1883 building was moved back, and the present sanctuary was built and joined to it. In 1901, the balcony was added in the sanctuary, and the brick Sunday school unit was added in 1909. The church bell was purchased and installed in 1920. In 1935, the Seventh Day Adventists bought the church for $3,500 and have used it for weekly Sabbath services since then. (Courtesy Pomona Public Library.)

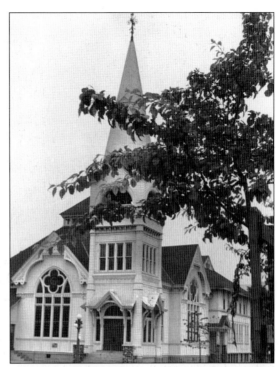

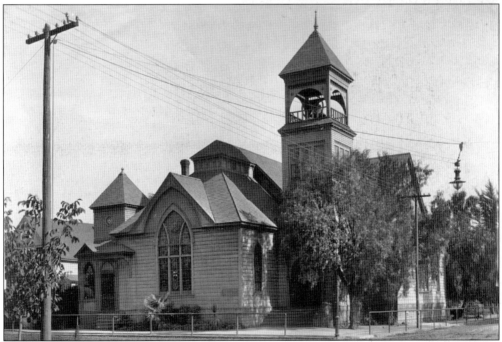

Rev. Richard C. Fryer organized the First Baptist Church in Spadra in 1870. Shortly after the members moved from Spadra to Pomona, they began working to build a church. This First Baptist Church building was located on the corner of Park Avenue and Fourth Street and served the congregation until the building was constructed on the corner of Garey and Holt Avenues. (Courtesy Pomona Public Library.)

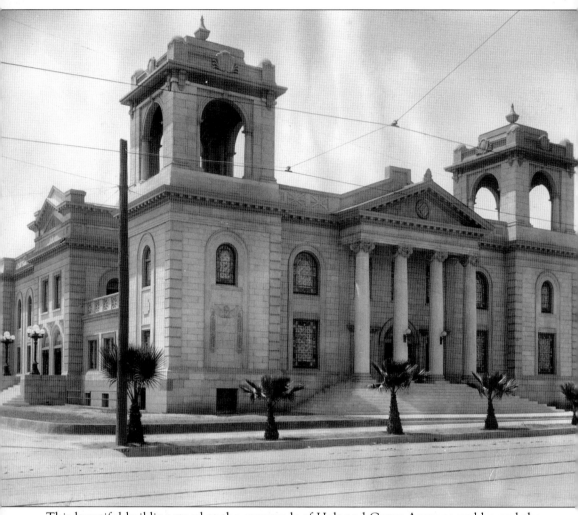

This beautiful building stood at the crossroads of Holt and Garey Avenues and housed the sanctuary of the First Baptist Church. Built in 1911, a wedding chapel and a church school were added in 1950. The wedding chapel was torn down when the new sanctuary was constructed. Numerous efforts by members of the preservation community to work with the church to save the building were unsuccessful after the U.S. Supreme Court ruled that buildings used for religious purposes were exempt from preservation ordinances. The Pomona City Council voted to allow the building to be demolished with no further requirements placed on the church. The building was totally destroyed in February 2005. Members of the community still grieve at the loss of this exquisite building. (Courtesy Pomona Public Library.)

Seven
THE CITY OF TECHNOLOGY

The population grew steadily, and by 1953, Pomona had more than 40,000 residents; however, the retail trading population was over 180,000 residents. Although hundreds of new homes were being built, agriculture was still very important to the economy, with 100 acres planted in truck gardens, alfalfa, orchards, vineyards, and citrus groves.

Pomona was a transportation center, with three transcontinental railroads running through the city and bus lines radiating east, west, north, and south. It was Southern California's most centrally located city, not more than two hours' drive to the mountains, beaches, or desert.

The industrial stability and growth of Pomona was readily apparent during the mid-decades of the 1900s. Pomona Tile Manufacturing Company was well established, with an annual production payroll of over $1 million. H. W. Loud Machine Works employed 450 employees. In addition to the two biggest industries, Convair Pomona Plant and Potlach Paper Mill, Hazel Atlas Glass, Brogdex Company, Bestform Foundations, Malwin of California, and Wayne Manufacturing Company all employed over 100 workers each. Pomona was also the division office for the Southern California Edison Company. Sears Roebuck and Company purchased 10 acres of land at the eastern edge of Pomona and opened a Class-A retail store with warehouse and other facilities in the mid-1950s.

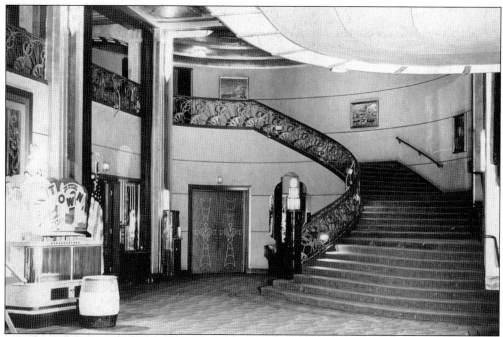

The Fox Theatre, which opened in April 1931 with a gala celebration of stars, officials, and Fox executives, was designed to be one of the finest theaters in the nation. The poured-in-place concrete and steel construction of the building in the art deco/zigzag moderne style made it virtually fireproof. The landmark tower rises 81 feet above the street and the "FOX" lettering is 25 feet high. (Courtesy Gene Harvey.)

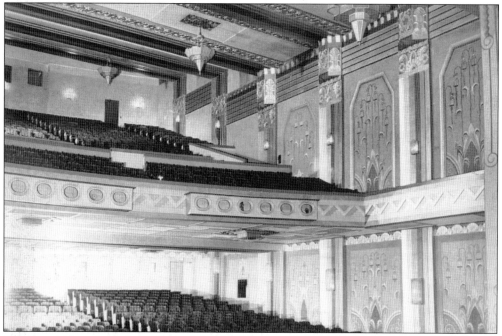

The beautiful work on the ceiling of the Fox Theatre is still visible today and is in the process of being restored. (Courtesy Gene Harvey.)

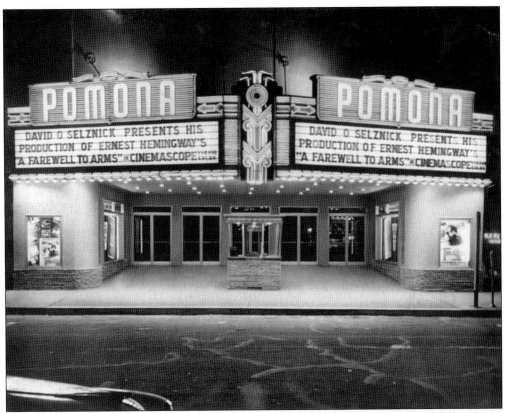

The marquee across the front of the theater has been modified several times. It announced the movies being shown and is in the process of being restored. (Courtesy Gene Harvey.)

An advertisement for a preview at the Fox Theatre appeared in a 1935 edition of the *Pomona Progress Bulletin*. The Pomona Fox was a favorite spot of the film industry to show previews as the reaction of the Pomona viewers was a good indicator of the reaction of the entire country. (Courtesy HSPV.)

In 1949, the office of the chamber of commerce was located at 146 East Third Street. The photograph shows the smaller metallic statue, a replica of the goddess Pomona statue in the library, which sat proudly in front of the office. The chamber has been unable to locate the smaller statue. (Courtesy HSPV.)

This post office was on the corner of Fourth Street and Garey Avenue. The cost of the property was $45,000, with the federal government appropriating $15,000 and the citizens raising the remaining $30,000. The corner stone was laid on September 1, 1931, with John C. Stewart, grand master of the California Masonic jurisdiction, fitting the stone in place. Built at a cost of $240,000, the building was dedicated on January 23, 1932, and opened for business two days later. (Courtesy HSPV.)

As late as 1954, the downtown area of Pomona continued to experience serious problems with flooding whenever there was a heavy rainfall. City crews are working late into the evening to distribute sandbags to businesses in the downtown area. (Courtesy HSPV.)

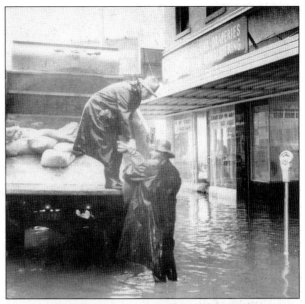

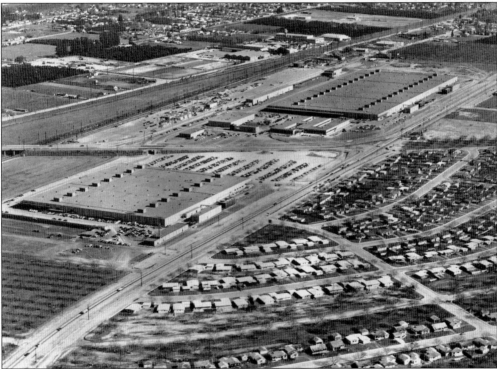

In 1953, the engineering and employment departments of Convair Aircraft Corporation Guided Missile Division were located at 305 East Second Street and other operations at 585 West Second Street. Convair was utilizing the Naval Ordinance Facility on Mission Avenue and employed 3,000 with a planned expansion to employ 5,000 workers. In 1950, General Dynamics purchased Convair, and the Pomona plant became a division of General Dynamics. General Dynamics eventually employed more than 14,000 people. The Red Eye, the Stinger, the Standard Missile, and the Phalanx, all critical defense weapon systems, were developed at this facility. (Courtesy HSPV.)

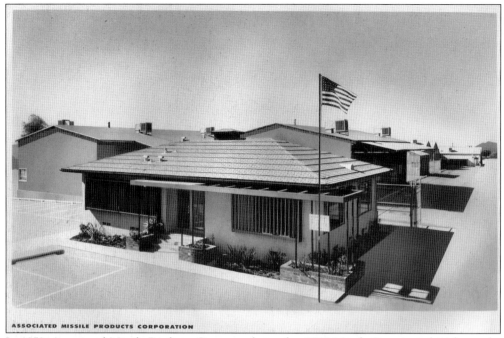

In 1958, Associated Missile Products Company, located at 2709 North Garey, was bought out by Marquardt Aircraft Company. In 1959, Marquardt created a new Nuclear System Division, and the Pomona Division was incorporated into the new division located in Van Nuys. (Courtesy HSPV.)

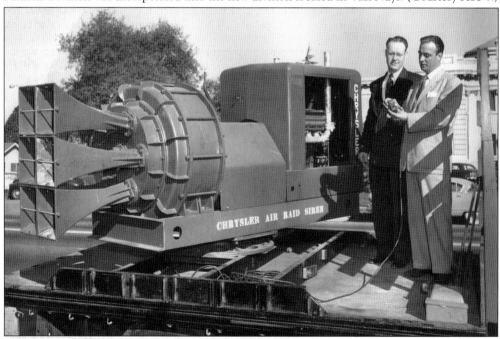

Bob Ross and Elias Crisp are shown with Pomona's air-raid siren in 1953. The siren was used to alert residents of impending disasters and was tested at a pre-determined set time each month so residents would be familiar with the sound and would know that it was a true emergency if it was heard at a different time. (Courtesy HSPV.)

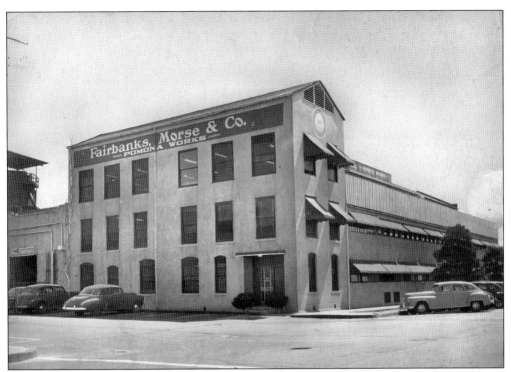

One of the early companies, Pomona Pump Company, was purchased by Fairbanks Morse and Company. This photograph was taken in 1953 when the manufacturing facility was located at 206 East Commercial Street and employed 500 people. Paul R. Floyd was the pump manufacturing manager. (Courtesy HSPV.)

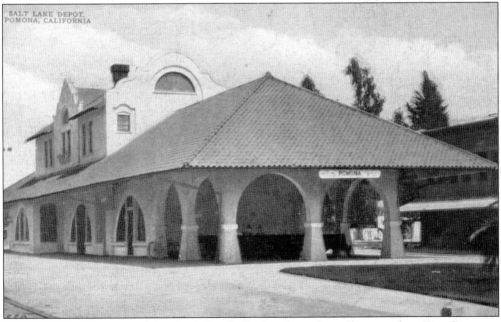

The new Pomona Depot of Southern Pacific Railroad was formally opened on First Street on January 14, 1941. (Courtesy Pomona Public Library.)

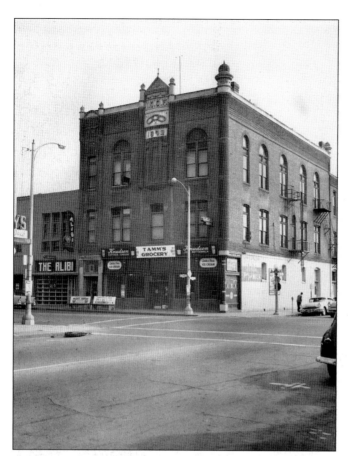

The lodge building for the Fraternal Order of Eagles Aerie No. 2215 was located at 484 West Second Street on the corner of Park Avenue. It was demolished in 1956. (Courtesy HSPV.)

Majestic Club
Dancing
Complete Bar Service
West Valley Blvd. and Union.
One Block West of Death Curve.

This advertisement appeared in the 1937 issue of the *Pomona Progress Bulletin*. Death Curve was located in western Pomona on Valley Boulevard. (Courtesy HSPV.)

This photograph of the intersection of Garey and Lincoln Avenues was taken when the overpass for the San Bernardino Freeway was being constructed. Tall palm trees lined the west side of Garey Avenue. The river-rock entrance with globes to Lincoln has long been removed. (Courtesy HSPV.)

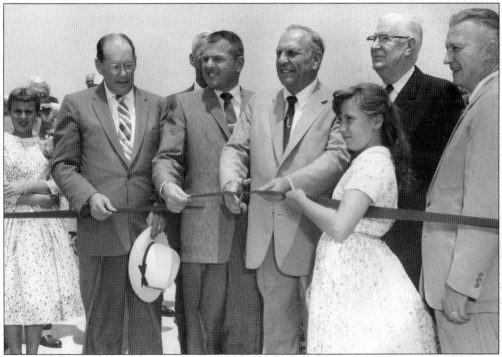

Completed through Pomona in 1954 at a cost of $7.85 million, Pomona fought for the 10 Freeway to be routed north of the Ganesha Hills to leave the city's main business center and the park intact. Reluctantly the Pomona City Council agreed on the route over the Ganesha Hills and around the southern flank of the park and the fairgrounds. (Courtesy HSPV.)

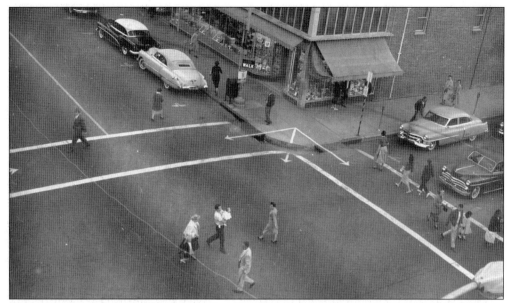

F. W. Woolworth Company was located at 235 West Second Street when this photograph was taken in 1956. The manager was Ray A. Beck. Woolworth and other similar stores were often referred to as the five-and-dime or the 10¢ store as it was a low-end department store that carried the full array of items, including live fish, live birds, and all pet supplies. It was every child's favorite place, with a lunch counter in the basement. (Courtesy HSPV.)

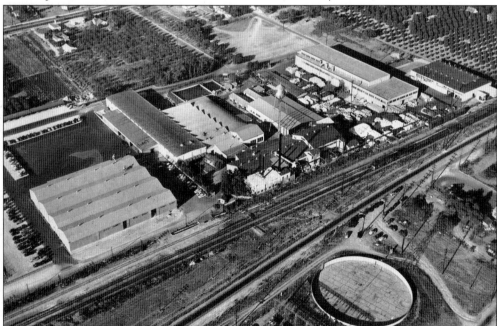

The aerial view of the Potlach Forests, Inc., plant in Pomona was taken in October 1956, a few years after the company purchased the Fernstrom Paper Mills. The plant was located at 1450 West Holt Avenue, and the general manager was W. J. Culverhouse. Potlach doubled the size of the plant and expanded its production. Potlach was one of the largest producers of hard tissue paper in the United States. (Courtesy HSPV.)

Charles Weinberg established Wayne Manufacturing Company at 1201 East Lexington Avenue in 1947. In addition to manufacturing street sweepers, the company manufactured water trucks and power vacuums. (Courtesy HSPV; donated by Vince Carpio.)

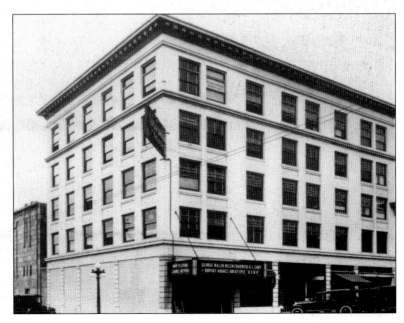

The First National Bank Building, located at 301 West Second Street, was built in 1924 when the old one was demolished. The six-story building is an excellent example of the neoclassical style of the 1920s. (Courtesy HSPV.)

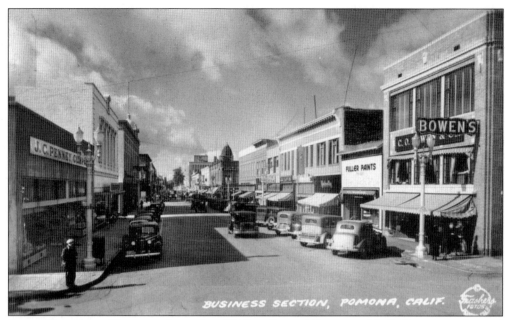

Bowen Department Store was located at 197 East Second Street, and J. C. Penney was located across the street at 176 East Second Street. (Courtesy HSPV.)

The opening of the Towne Avenue underpass in 1957 was met with much excitement. In addition to the traditional ribbon cutting, a pageant was held, and the selected young woman crowned Miss Underpass. A parade was also held. (Courtesy HSPV.)

The Pomona Valley Mall was located on East Holt between East End and Mills Avenues. Sears formed the anchor and was located at the eastern end of the mall. Originally a one-story, outdoor mall, in later years a roof was added to cover the breezeway. The mall rapidly deteriorated once Sears moved to the Montclair Plaza. Today the facility is owned by the Pomona Unified School District and houses a high school of choice, the Village Academy, and Pueblo Elementary and serves numerous other school functions. (Courtesy HSPV.)

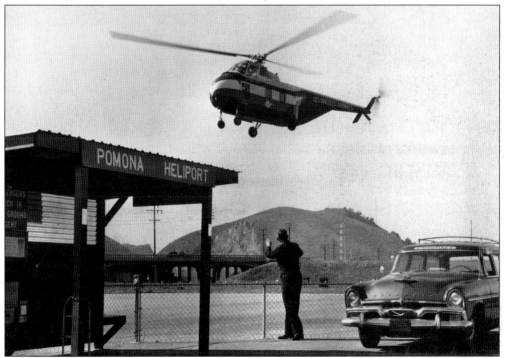

The City of Pomona was concerned about public transportation and how to get people to the downtown without taking up all of the room for parking lots. A heliport was opened up on First Street. It was seen as a great step in combating the traffic congestion problem. (Courtesy HSPV.)

Designed by local artist Millard Sheets, whose mosaics and other art works grace many of the fountains, the Pomona Pedestrian Mall consisted of nine downtown blocks and was built by private citizens as part of a 10-year community redevelopment plan to eliminate blight and deal with a lack of off-street parking, traffic congestion, and inadequate public transportation. (Courtesy HSPV.)

In addition to the works of Millard Sheets, the works of artists Betty Davenport Ford, Albert Stewart, and John Svenson were also featured in the fountains and pools to create a place of shade and beauty. (Courtesy HSPV.)

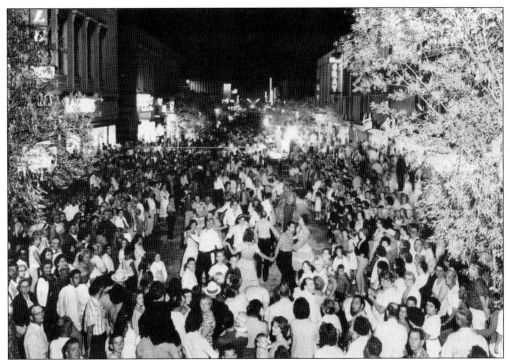

Pomona Mall Dedication Day on October 15, 1962, was an all-day celebration attended by thousands of people. The culminating event was the Dedication Dance in the evening, with Johnny Catron and his 14-piece band playing swing music. (Courtesy HSPV.)

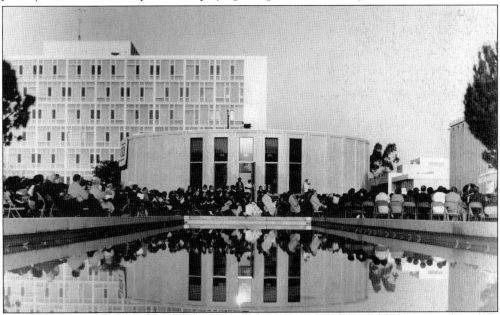

The New City Hall Dedication and Open House Ceremonies were held on January 6, 1969. The two-story structure with a basement has a total of 69,000 square feet. The city council chamber, with seating for 150, is contiguous to the city hall and was designed for multi-purpose community use. This photograph was taken on Easter Sunday during sunrise services. (Courtesy HSPV.)

Across America, People are Discovering Something Wonderful. Their Heritage.

Arcadia Publishing is the leading local history publisher in the United States. With more than 3,000 titles in print and hundreds of new titles released every year, Arcadia has extensive specialized experience chronicling the history of communities and celebrating America's hidden stories, bringing to life the people, places, and events from the past. To discover the history of other communities across the nation, please visit:

www.arcadiapublishing.com

Customized search tools allow you to find regional history books about the town where you grew up, the cities where your friends and family live, the town where your parents met, or even that retirement spot you've been dreaming about.